Tibetan Pilgrimage

Architecture of the Sacred Land

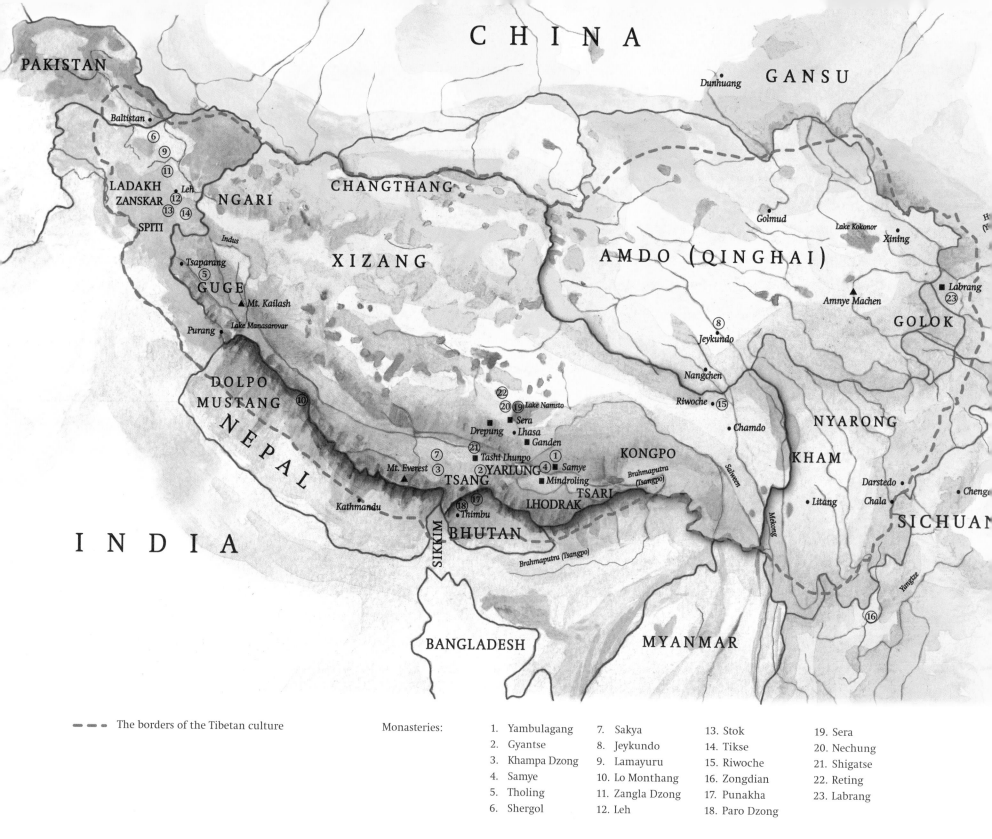

CHINA

PAKISTAN

GANSU

Dunhuang

Baltistan

⑥
⑨
⑪
LADAKH
ZANSKAR Leh ⑫
SPITI ⑬ ⑭

NGARI

CHANGTHANG

Golmud

Lake Kokonor Xining

Indus

XIZANG

AMDO (QINGHAI)

■ Labrang
㉓

Tsaparang

⑤
GUGE

▲ Mt. Kailash

Amnye Machen ▲

GOLOK

Purang Lake Manasarovar

⑧
Jeykundo

DOLPO
MUSTANG ⑩

Nangchen

Riwoche ⑮

NYARONG

NEPAL

㉒
⑳⑲ Lake Namsto
■ Sera KHAM
Drepung ■ •Lhasa
㉑ • Chamdo
⑦ ■ Ganden KONGPO

Mt. Everest ▲ ⑦ ■ Tashi Ihunpo ①
③ ②YARLUNG ④ • Samye TSARI
TSANG ■ Mindroling
Kathmandu LHODRAK

Sahveen

Litang Darstedo

Chala • Chengde

⑱⑰
• Thimbu
SIKKIM BHUTAN Brahmaputra (Tsangpo) Mekong SICHUAN

INDIA

Brahmaputra (Tsangpo) Yangtze

⑯

BANGLADESH MYANMAR

- - - - The borders of the Tibetan culture

Monasteries:

1. Yambulagang
2. Gyantse
3. Khampa Dzong
4. Samye
5. Tholing
6. Shergol

7. Sakya
8. Jeykundo
9. Lamayuru
10. Lo Monthang
11. Zangla Dzong
12. Leh

13. Stok
14. Tikse
15. Riwoche
16. Zongdian
17. Punakha
18. Paro Dzong

19. Sera
20. Nechung
21. Shigatse
22. Reting
23. Labrang

Tibetan Pilgrimage

Architecture of the Sacred Land

Text and watercolors by Michel Peissel

Harry N. Abrams, Inc., Publishers

To Roselyne and Valentin

Foreword

I

The Dynasty of Songtsen Gampo

Between the seventh and ninth centuries the Tibetan kings established a nation in the heart of Asia, with a language, traditions, art, and architecture that have endured for fourteen centuries.

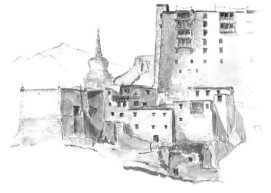

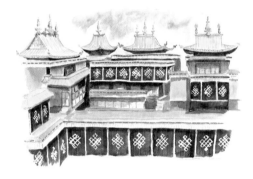

Foreword

On my first visit to the Himalayas, I lost my heart to the Tibetan people. What seduced me was their sense of humor and open-mindedness, their emphasis on intelligence and wit above all virtues, and their belief that hypocrisy and pomposity are the worst of sins. I was surprised to discover that in the Tibetan language the words for beauty and happiness are interchangeable. Tibet is a relatively poor country, but the Tibetans take great care to make things beautiful. They braid their ponies' tails and decorate their houses, asking, "Who would want an unhappy pony or home?" They live in the midst of the staggering beauty of the Tibetan highlands, lit by the golden clarity of the high altitude.

Fifteen centuries ago a Chinese chronicler described Tibet as covered with towers and forts. This is still true today, with the addition of the magnificent temples and monasteries that appeared in the wake of Buddhism. As I wandered the Tibetan highlands I was constantly struck by the majestic elegance of these buildings set upon crags, enhancing the natural landscape. Thus was born my interest in Tibetan architecture. Professor Rolf Stein, the distinguished Tibet scholar, served as my thesis advisor, and assisted me in planning my journeys to the most remote regions of Tibet. On my return he helped me to better understand what I had seen or brought back. He encouraged me to record everything during my travels, because we know so little about Tibet and its customs.

Year after year, for forty years, I traveled on foot and horseback into the far recesses of the Tibetan world. I visited every temple, monastery, tower, and fort on my route. I now have more than 10,000 photographs, but few do full justice to the elegance and beauty of the architecture. It was by chance that I attempted my first watercolor, depicting a modest Bhutanese house. Then I understood that in order to illustrate a building, one has to comprehend the process of its construction: Is the material wood, stone, adobe, or brick? How did the carpenters assemble the window frames? The artist must learn and analyze what the lens of a camera cannot see.

While painting the illustrations in this book, I constantly referred back to information I had gathered from masons and carpenters. Although my work is but a poor reflection of the genius of Tibet's master builders, I hope that this book may contribute in a modest way to a greater appreciation of Tibetan architecture and help inspire the admiration it deserves. Beyond their elegance and originality, Tibetan buidings

are the undeniable witnesses to the true geographical range of Tibetan culture and its enduring vitality.

Standing stones, ancient graves, rock carvings, and stone shelters reveal that Tibet was inhabited in prehistoric times. A campsite in Amdo that dates back 8,000 years shows that the ancient lifestyle of the nomadic herders of the Tibetan highlands has remained very much the same.

Tibetan written history begins in the mid-seventh century with the creation of a Tibetan alphabet, but earlier Chinese records describe the towers and fortresses of Tibet, from which rival princes ruled the land. Songtsen Gampo, the founder of Tibet's first royal dynasty, united these local leaders in the seventh century, establishing an empire that dominated central Asia for three centuries.

Tibet developed into one of the great cultures of Asia, whose achievements in the arts, poetry, literature, engineering, medicine, and architecture rival those of neighboring China and India. The dynamic sophistication and originality of the Tibetan way of thinking exerted an influence much larger than the country's small size would suggest.

Buddhism came to Tibet from India and was later backed by Mongol military power. In the seventeenth century, as religious leaders sought greater control over the country, Tibet plunged into a dark age of civil wars, isolation, and bigotry. The Dalai Lamas' bid for political power failed, resulting in the fragmentation of Tibet. While the Dalai Lamas ruled over the central third of the country, the rest of Tibet, divided and impoverished, was taken over by India, Pakistan, Nepal, and China.

Tibet has disappeared from the political maps of the world, but the Tibetan people have survived. Their vitality stems from a culture that puts power in the hands of the young rather than the old, as in most agricultural societies. Today, with the help of the Internet, television, radio, and tourism, the Tibetan people are more aware than ever of their common heritage. They are certain to outlive the religious and political forces that have caused their momentary eclipse, and hope exists that Tibet will one day regain its independence.

In the meantime every facet of Tibetan culture is still very much alive, from Ladakh to Gansu, Mustang to Mongolia, Bhutan to Sichuan, where Tibetan books, buildings, and works of art continue the cultural traditions and customs of a land long considered one of the most sophisticated in Asia.

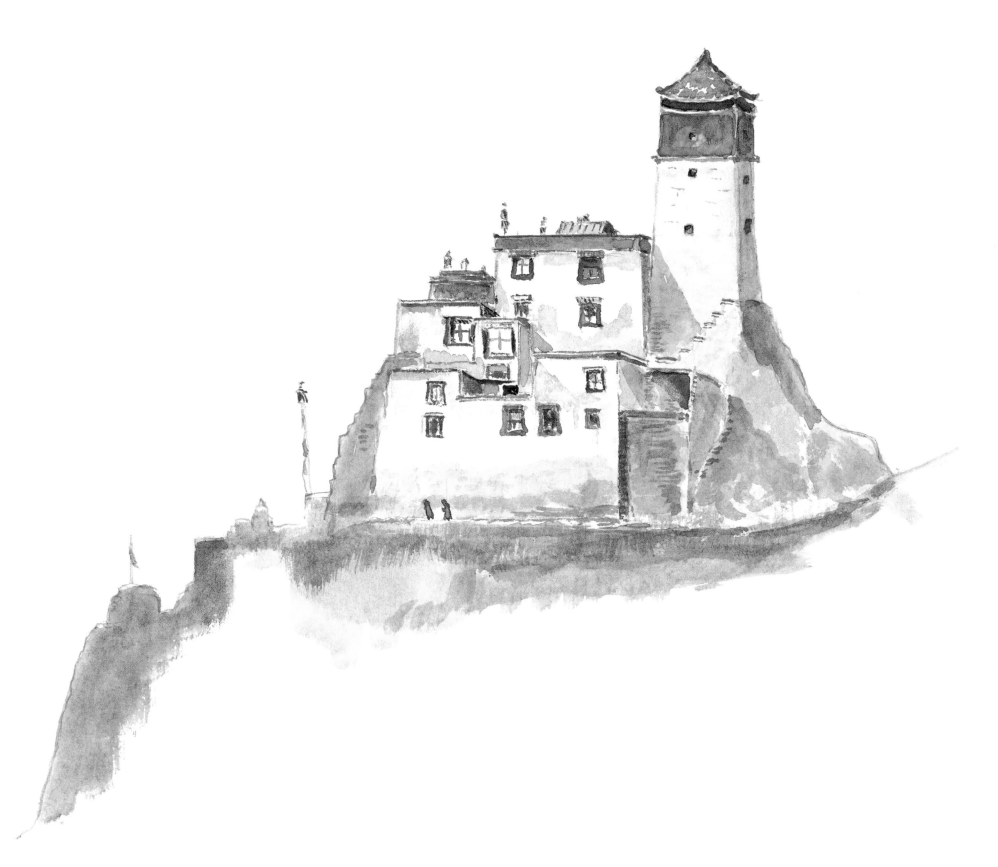

The Dynasty of Songtsen Gampo

Yambulagang is believed to have been the home
fortress of Songtsen Gampo, the first emperor of Tibet.

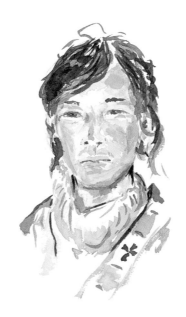

A young Tibetan farmer.

11 The Tibetans are excellent farmers, able to obtain surprisingly high yields of barley per *ke* of land. A *ke* is a measure of barley, and one *ke* of land is the surface that can be sown with that amount.

Our pilgrimage begins at Yambulagang, the castle-fortress of the Yarlung kings. Here, in 627, the thirteen-year-old Songtsen Gampo (r. 627–649) became the thirty-third Yarlung king. He departed the Yarlung Valley to unify Tibet, becoming the country's first emperor. Yambulagang is the oldest building in Tibet, modified over the centuries, nearly destroyed by the Chinese army in 1959, and further damaged by the Red Guards. Yet it still stands as a symbol of the Tibetan nation. Tibet's culture, religion, and language, largely created by Songtsen Gampo, has endured for fourteen hundred years throughout the vast territory over which he reigned, and his name is still revered.

Tibet has two very different communities, whose lifestyles have remained much the same over the centuries. Farmers live in scattered villages and grow barley almost exclusively, in fields with complex systems of irrigation. To complement their diet and income, they raise a few yaks, horses, sheep, and goats. In the winter the farmers travel to trade. They live in homes commonly made of sun-dried earthen bricks. Most farmers have special skills as architects, masons, carpenters, potters, or artists. Metalworking, however, was traditionally reserved for the *gara*, outcasts considered impure and often forbidden to live within the village enclosure. They were also banned from entering beyond the outer porch of the monasteries. However, the *gara* were remarkable blacksmiths and goldsmiths, responsible for making Tibet's renowned armor and swords.

Tribes of nomadic herders comprise the other segment of Tibet's population. They live in vast tents made of black yak hair, shifting campsites from one pasture to another, according to season, as often as ten times a year. Proud and rich, by the farmer's standards, the herders employ farmers to tan their sheepskins

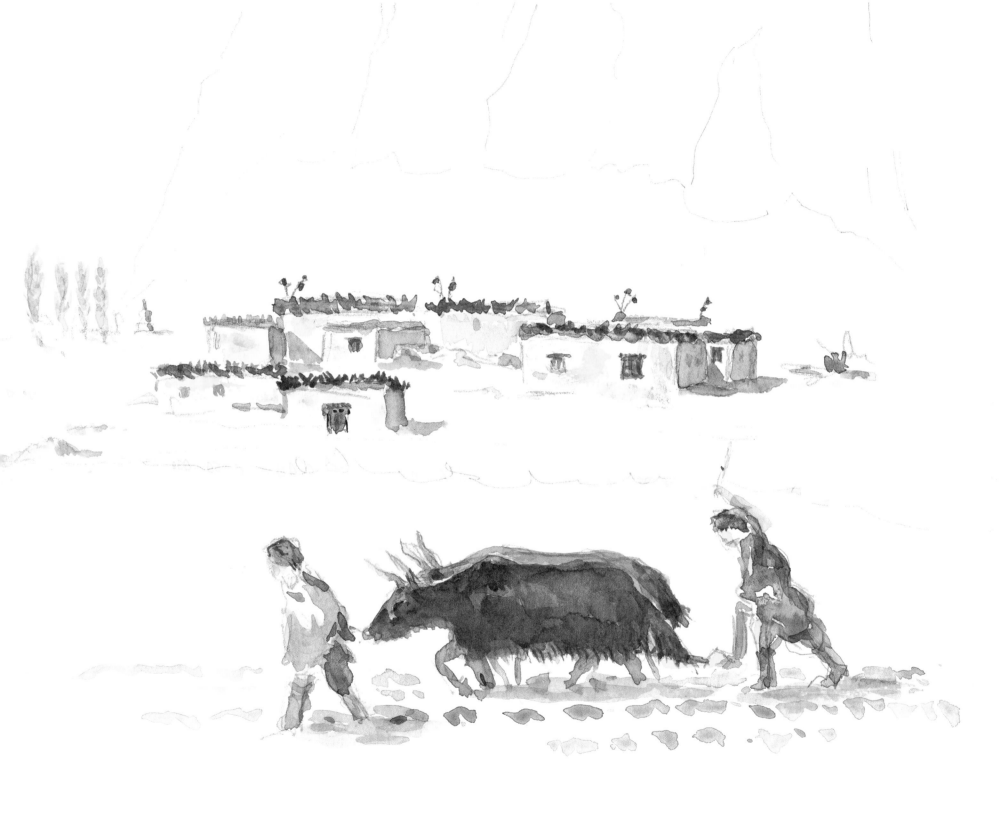

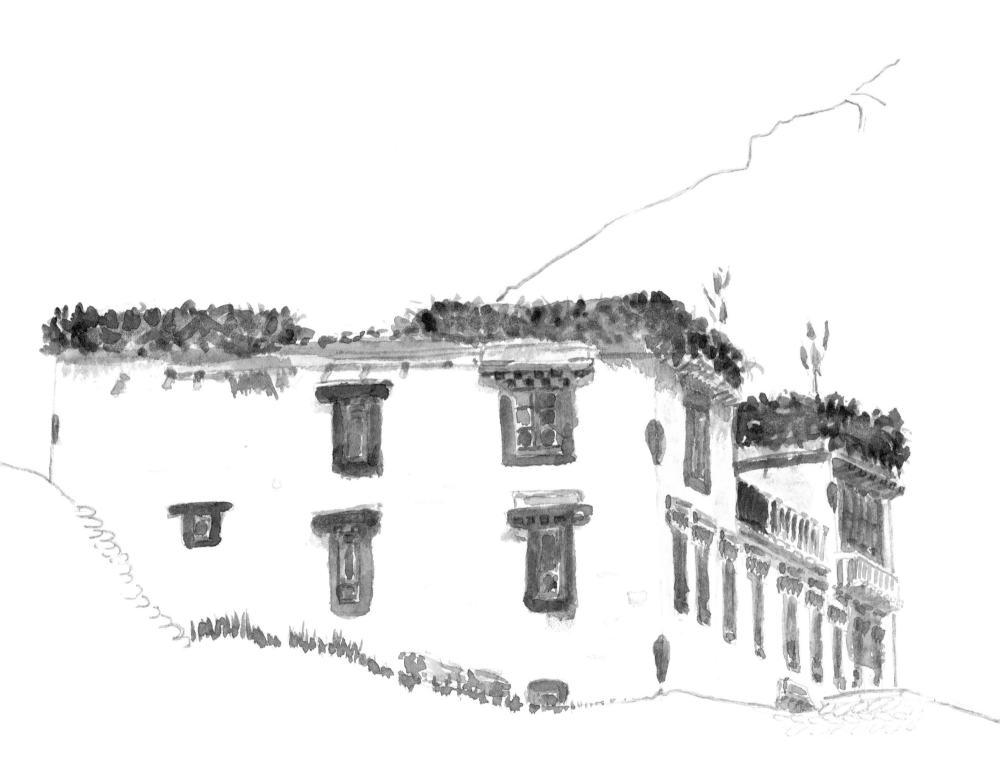

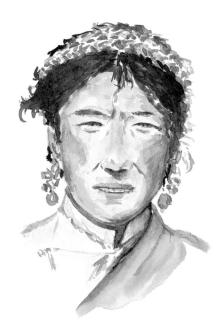
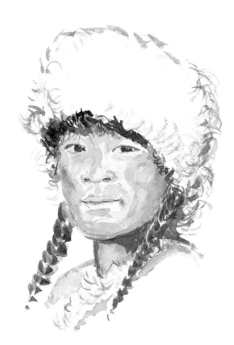

Two nomads, a young woman and a young man, stand beside a prosperous farmer (center). Tibetans usually wear a great deal of jewelry, but they save their most elaborate outfits for holidays.

12 A fine homestead in Ladakh.

13 Even the simplest hut, such as the one pictured here, contains hints of grander Tibetan architecture. The wood on the roof prefigures the friezes that top monasteries.

16 Elaborately decorated tents are very popular with the nomads of Tibet. Farmers also use tents during trading journeys and picnics, as well as to receive holy lamas.

17 Black tents of woven yak hair are used by all Tibetan herders, with slight variations in size and shape among tribes.

and collect hay. They live off the meat and dairy of their yaks, sheep, and goats. They also eat barley, which they acquire from the farmers in exchange for wool, dried meat, butter, cheese, and the salt they collect from Tibet's northern lakes.

The herders live a lonely life, as scarcity of grass forces them to pitch their tents far from each other. They live with only their nuclear family and perhaps the husband's elderly parents. But once a year the nomads of a region pitch their tents together, forming a vast city of decorated cotton tents. Festivities, including horse races and dances, last five or six days, and marriages are arranged. Afterward the herders disperse and return to their solitary lives.

The nomads are generous donors to the monasteries. They traditionally supply the monks with butter, used both as food and as fuel for lamps. They also donate dried meat and yards of yak-hair tent material, used to enclose the open porches of the monasteries.

King Songtsen Gampo introduced Buddhism to Tibet after marrying two Buddhist brides, a Nepalese princess and a Chinese princess. Songtsen and his wives founded the first Tibetan Buddhist temples in Lhasa, the Jokhang and the Ramoche, to hold the statues of Buddha that the princesses brought with them. The Jokhang housed the Nepalese queen's Akshobhya Buddha, while the Ramoche housed the Chinese queen's Sakyamuni Buddha, known as Jowo. (The placement of the two statues was later reversed, and the Jokhang became home to the gold statue of the crowned Buddha.) Songtsen Gampo changed the name of the region from Rasa, which means "land of the goat," to Lhasa, "land of the gods."

The Jokhang is the holy center of Tibet, a vast conglomerate

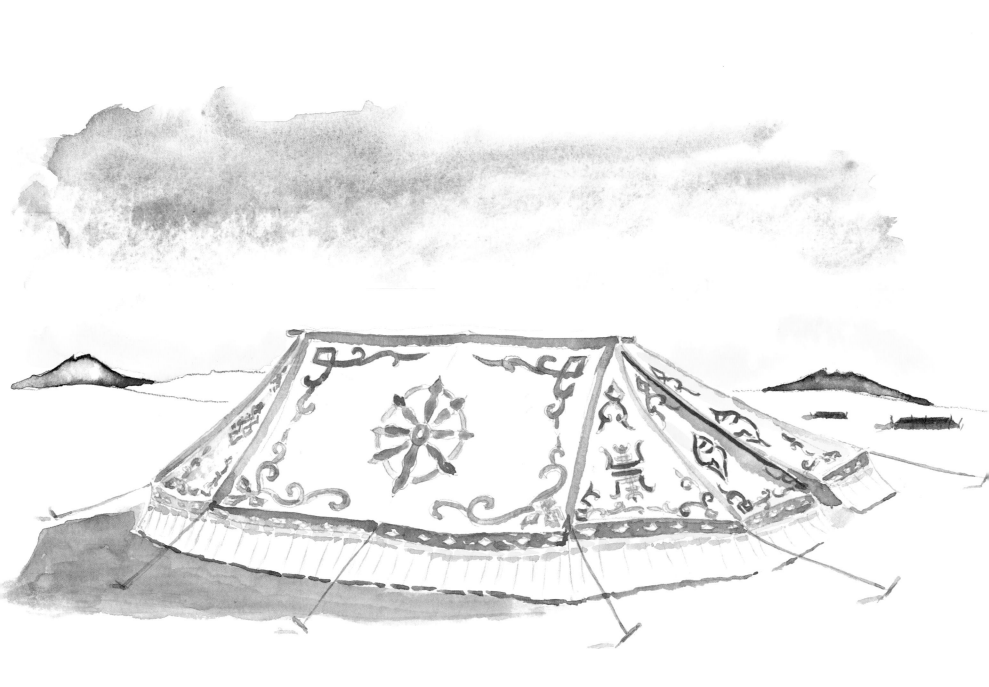

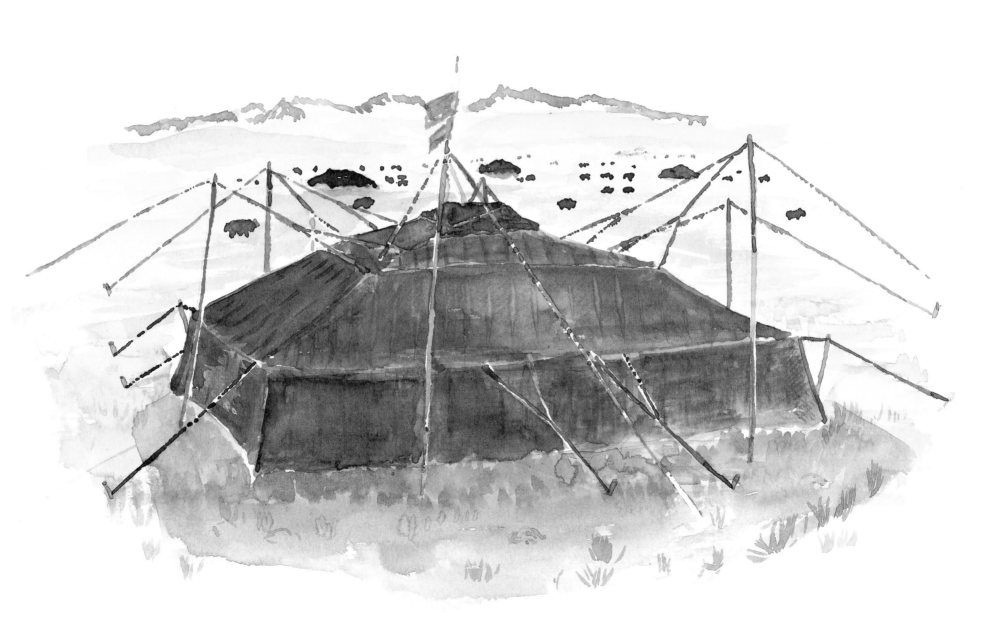

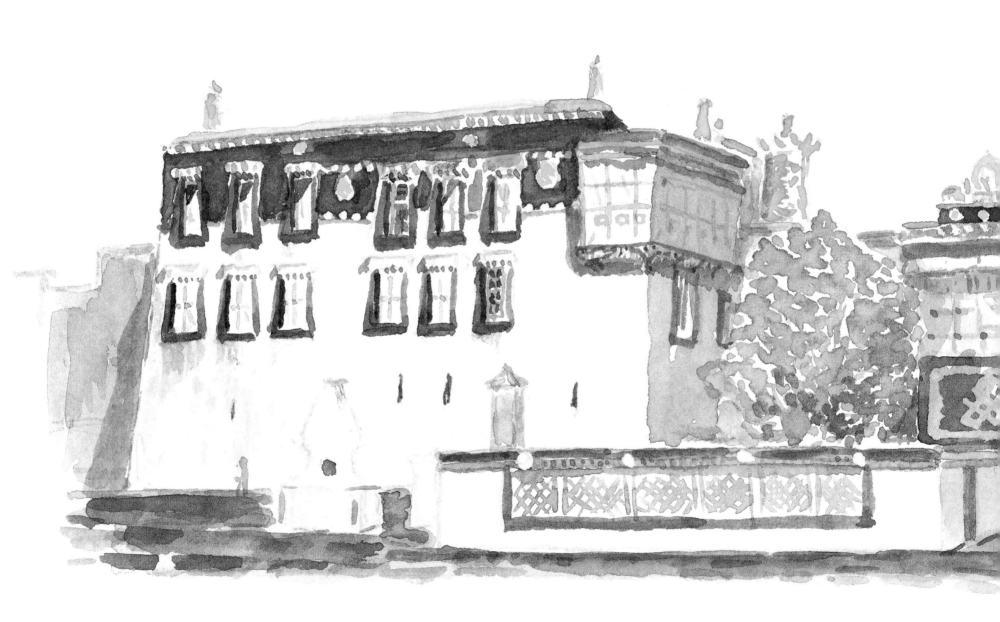

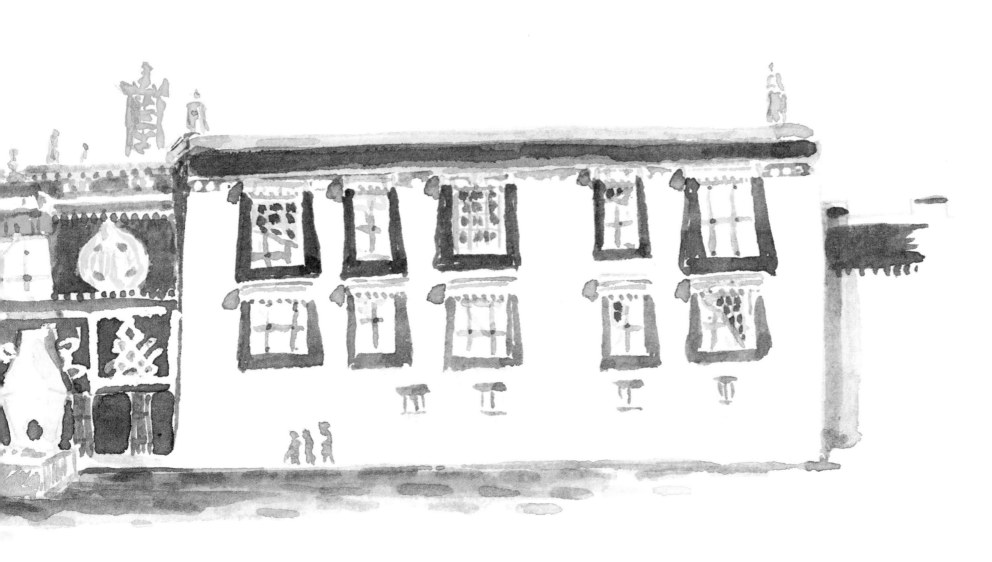

18–19 The Jokhang temple in Lhasa houses the Jowo, a statue of the Sakyamuni Buddha brought to Tibet by the Chinese wife of King Songtsen Gampo. The Jokhang is the most sacred site for Tibetan Buddhists.

Every Tibetan hopes to visit the Jokhang at least once in his lifetime, to prostrate himself before the holy doors.

of assembly halls and dark chapels built around and above the earliest shrines, decorated with carved lintels in the ancient Buddhist style of Nepal and India. Here in front of the temple pilgrims prostrate themselves. Most come in the winter, traveling from the far corners of the Tibetan world, and some take years to make the pilgrimage. Like most buildings, the exterior of the Jokhang is decorated with curtains and drapes, ever-changing in color and constantly animated by the wind, a reminder of the nomadic origins of so many Tibetans.

The Ramoche is the second-holiest shrine in Lhasa. Its simple lines illustrate the style that has typified Tibet for fourteen centuries: sloping exterior walls built to contain loose rubble and resist earthquakes; heavy, dark-brown friezes that recall the firewood stacked on the roofs of peasant dwellings; and windows framed in black to keep away demons (in eastern Tibet they

are white). Long wooden latticework galleries light the rooftop apartments of monks and dignitaries. Before the introduction of glass, latticework was sealed by translucent paper and further insulated by outside drapes of white cotton bordered in blue. Tent material woven from yak hair covers the open porches to keep out the cold. On the rooftops stand holy parasols of cloth and yak wool or gilt brass. More than sixty percent of the facade is draped with cloth.

Although hailed as a holy king and later raised by the Buddhists to the rank of a saint, Songtsen Gampo was above all a brilliant strategist and administrator, more interested in building forts such as Khampa Dzong than monasteries. He waged war against the Mongols attempting to invade the Kokonor region of northern Tibet and against the Chinese in the east; he extended his dominion south into Bihar, while to the west he kept the Muslim Turks

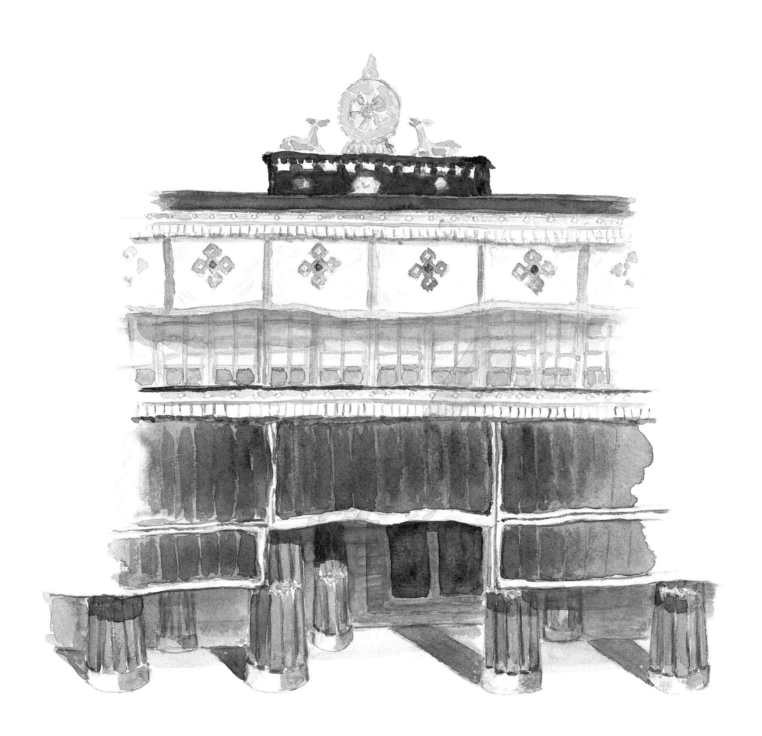

The dark borders around the windows are believed to keep out evil spirits. The cotton frills are changed every year.

23 The Ramoche temple was originally built to hold the statue of Buddha that is now in the Jokhang. Today Ramoche is home to a statue of the Akshobhya Buddha, brought to Tibet by the Nepalese wife of Songtsen Gampo.

at bay. The armies of Songtsen and his remarkable minister, Tongsten Yulsung of Gar, ruled central Asia and established the cornerstone of the Tibetan empire.

Farmers and nomads alike swore an oath of fidelity to Songtsen and were organized in fighting units sent to the four corners of Tibet. Rival princes were subdued, including the king of the mysterious federation of Zhang Zhung. An adept of the ancient Bon religion, the king of Zhang Zhung was eventually killed—perhaps with the help of his wife, the sister of Songtsen Gampo.

Each valley or region had its own fortress (*dzong*) and resident lord, or *Deba*, also known as the *Dzongpon* ("lord of the fort") or *Gyalpo* ("the victorious"), a title often translated as king. The local lords followed the will of the all-powerful emperor, but they were in charge of collecting taxes from the landowning farmers in their regions.

Songtsen introduced an original law that banned the sale or purchase of land. This protected the farmers' holdings "until the crows turn white." Songtsen's laws helped Tibet avoid the woes that have plagued other agricultural societies, where wealthy merchants or powerful leaders have often bought or appropriated land and turned farmers into serfs. However, farm owners were required to pay a land tax to the king or provide a service, such as being a soldier to the local fortress.

Fortresses appeared throughout the country, including the formidable citadel of Gyantse, the third-largest town. No one has counted the total number of fortresses that have been built in Tibet throughout history, but at one time there must have been more than three thousand—as many, if not more, than the number of monasteries in later times. One Chinese author claimed that a tower stood every three and a half miles. In addition to

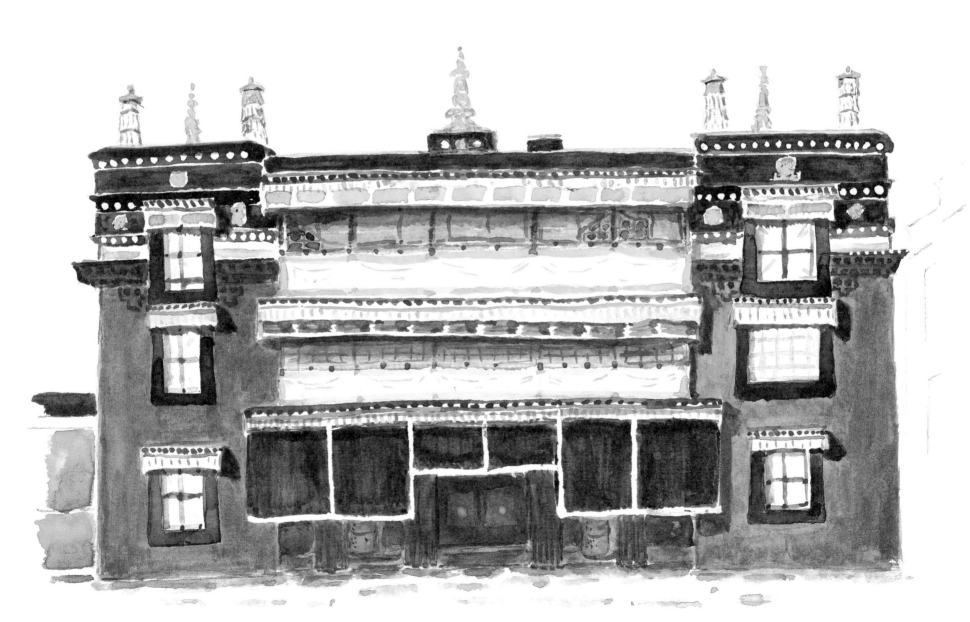

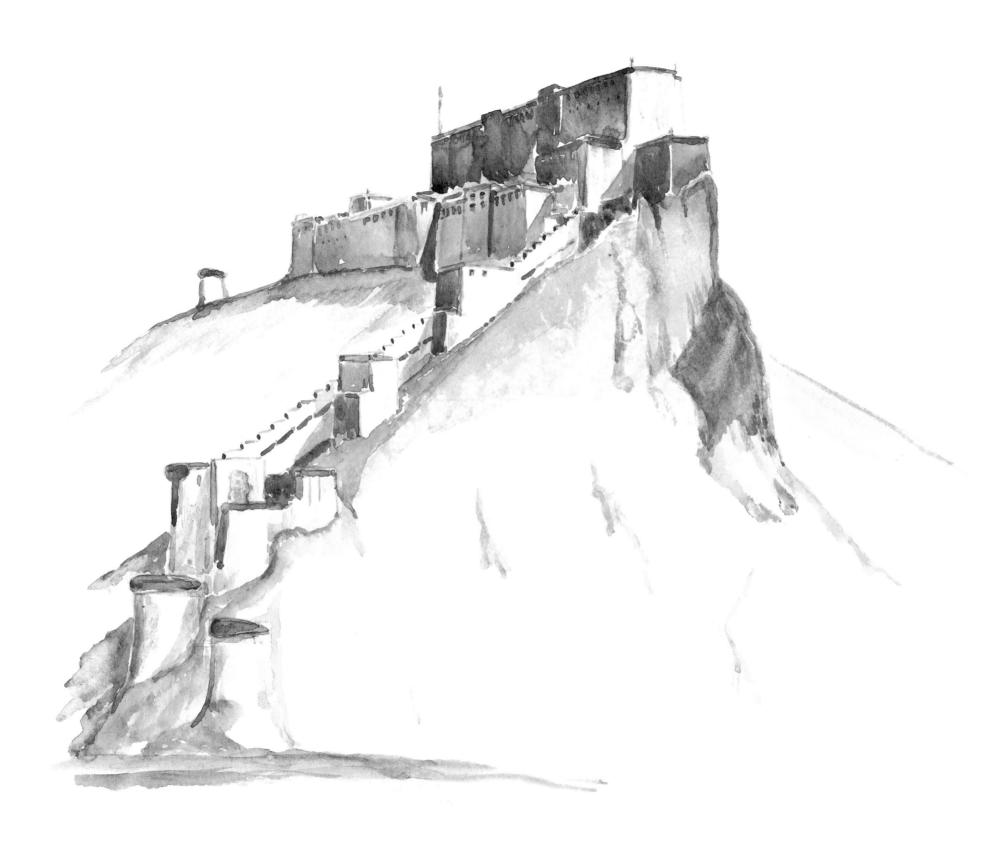

26 One of the amazing, freestanding towers that remain of the hundreds that once existed. Like this one, most of the towers are located in Kham, in eastern Tibet.

Khampa Dzong, close to the border of Sikkim, was occupied by the British in 1903 and later destroyed by the Chinese.

27 The citadel of Gyantse, prior to its partial destruction by the British in 1904.

near-constant war with neighboring countries, Tibet was prey to roving gangs who attacked caravans on lonely trails or raided isolated dwellings. Today more than 300 amazing freestanding towers still exist in eastern Tibet. Villages were built on crags, the houses clustered to form a fortified enclosure with narrow alleys between homes. Every house had a heavy door, locked at night and guarded by fierce mastiffs. During attacks the villagers could also find refuge behind the thick walls of the local fort.

The Bon religion remained popular in the country. Even the early Buddhist kings maintained some of the ancient traditions, such as building colossal tombs on elevated platforms, in which the bodies of deceased kings and queens were laid to rest, plated in gold, set in silver caskets, and surrounded by golden vessels and sculptures.

The Tibetan alphabet was created at the demand of Songtsen Gampo. With only thirty letters and five accents for vowels,

Tibetan is much easier to master than Chinese. Soon, despite countless local dialects and languages, everyone understood Tibetan. This lingua franca helped unite the nation politically and culturally. Across the Tibetan plateau the rule of the great Tibetan emperors set a pattern for the development of a Tibetan way of life. The great national epic of Tibet developed as bards spread stories of the ancient king Gesar of Ling. Gesar was in part modeled on the historical Tongsten Yulsung of Gar, the brilliant and powerful minister of Songtsen Gampo. According to the story, Gesar becomes king of Ling by winning a horse race, and in endless adventures he fights evil spirits, seduces women, and kills demons and rival kings. The epic was passed on orally, and there are hundreds of regional variations. Written transcriptions number thousands of pages, and new chapters are still invented today.

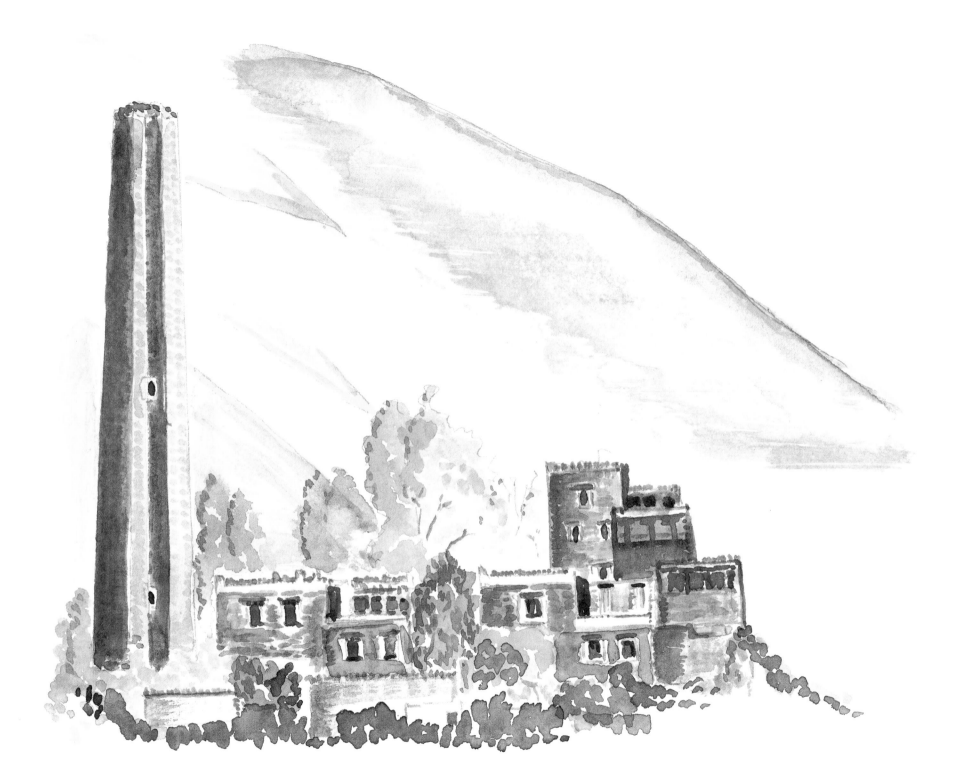

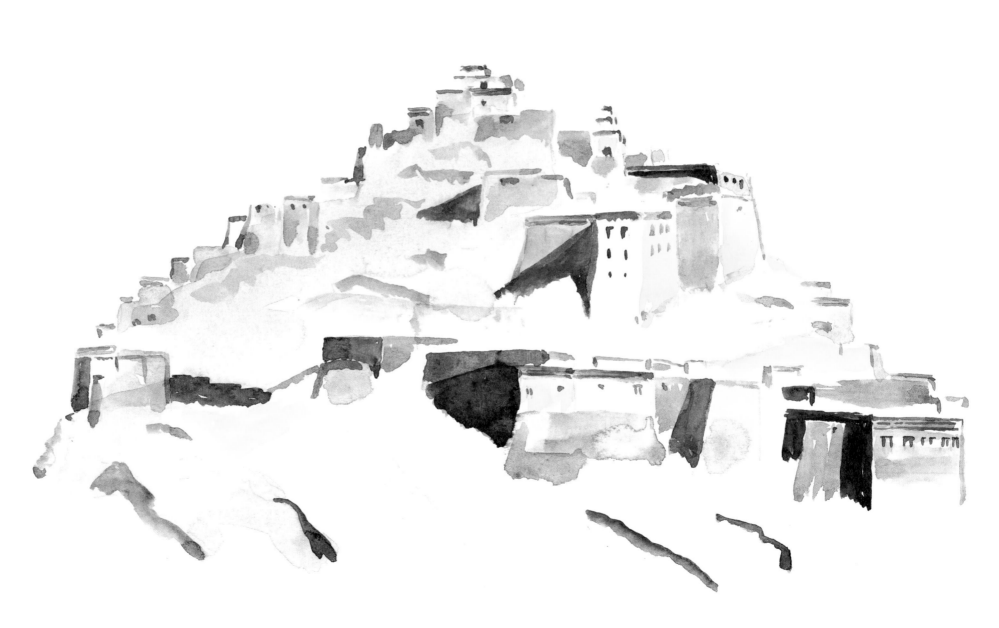

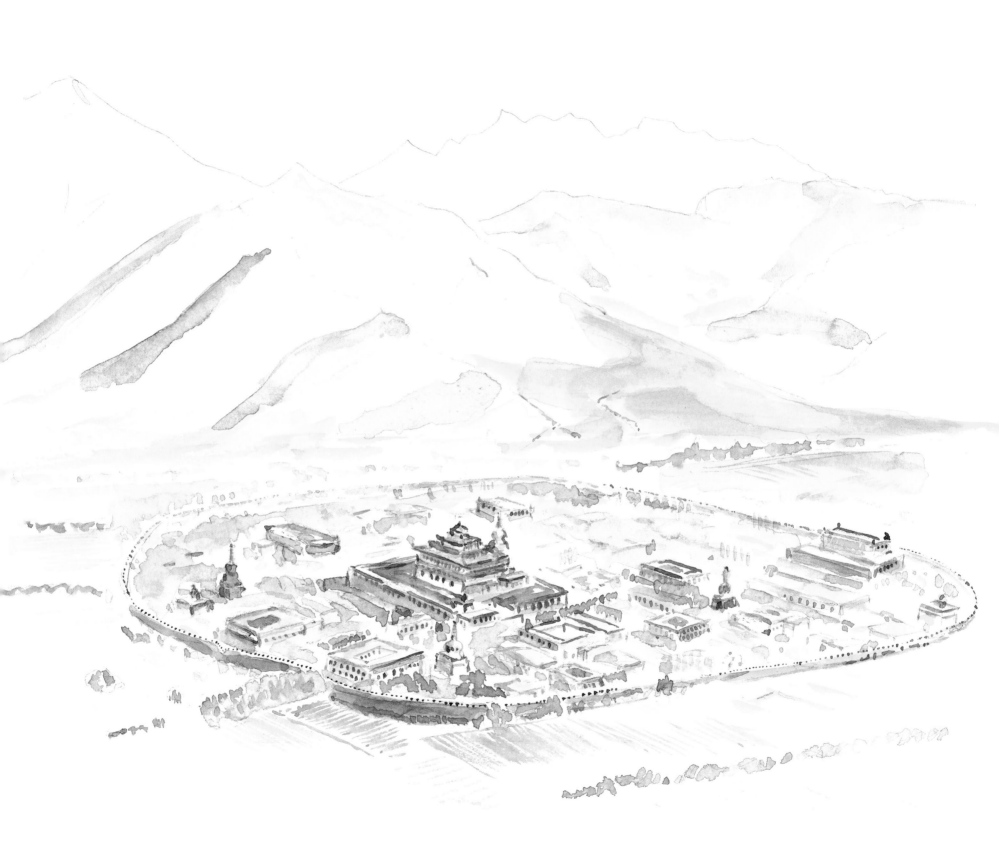

Samye, the first monastery in Tibet, is laid out in the form of a mandala.

During the reign of Trisong Detsen (r. 755–797), Tibet annexed large parts of China, receiving an annual tribute of 50,000 rolls of silk. When the Tang emperor failed to pay the tribute in 763, Tibetan troops conquered the rich capital Chang'an (modern Xian) and temporarily deposed the Chinese emperor. Trisong placed the brother of his Chinese wife on the throne, where he lasted three weeks. Sixteen years later Trisong founded the first monastery in Tibet, Samye. This impressive building reflects the Indian influence on Tibetan architecture, taking as its model the monastery of Odantapuri in present-day Bihar, in northeast India. The central assembly hall is surrounded by a circular wall that encloses four other temples, oriented north, south, east, and west, so that the whole represents a mandala, or sacred circle. Although ravaged by fire several times through the ages, Samye remains much in its original form. In 792 a historic debate took place at Samye between the advocates of Indian Buddhism and Chinese Buddhism. The Indian scholar won, thus determining the future shape of Tibetan Buddhism.

By the year 800 a Tibetan nation existed: a people who shared a spoken and written language, a national hero and epic, reverence for the founding fathers Songtsen Gampo and his descendants, and unique customs governing marriage, inheritance, and land tenure. Religion, which was later to gain such importance, "was little more than a court interest" at the time, as Hugh Richardson and David Snellgrove write in *A Cultural History of Tibet*. Buddhism did not receive much popular support in the first two centuries of its introduction. Many of the nobles resisted Buddhism, angry that their power had been decreased by the Yarlung dynasty, and the ancient Bon religion still had many adherents. In 836 King Ralpachan was assassinated by supporters

The main temple of Samye is a magnificent example of
Tibetan architecture.

of his older brother, Langdarma, who became king. Langdarma reversed the religious trend of the past two centuries and launched widespread persecution of Buddhists. He ordered the destruction of temples and forced monks to convert or be killed.

In approximately 842 King Langdarma was assassinated by a Buddhist monk. His death marked the end of the Yarlung dynasty and led to the collapse of centralized authority. Tibet lost its conquests in Turkestan and China but retained control over the entire high-altitude Tibetan plateau. This region extends 2,000 miles west to east—from Gilgit and Hunza to the mountains next to Sichuan—and 1,500 miles north to south, from the Silk Road at Sining to the borders of India and Burma and well into Yunan. This immense territory was first divided between the two sons of Langdarma and later split into a dozen semi-independent principalities. Buddhism faded, but the laws of Songtsen Gampo remained in effect, which helped the various kingdoms economically. Thus, a century after the death of Langdarma, rich lords could pay small fortunes to induce Indian scholars to cross the fearsome Himalayas to again teach the doctrines of Buddha to Tibetans.

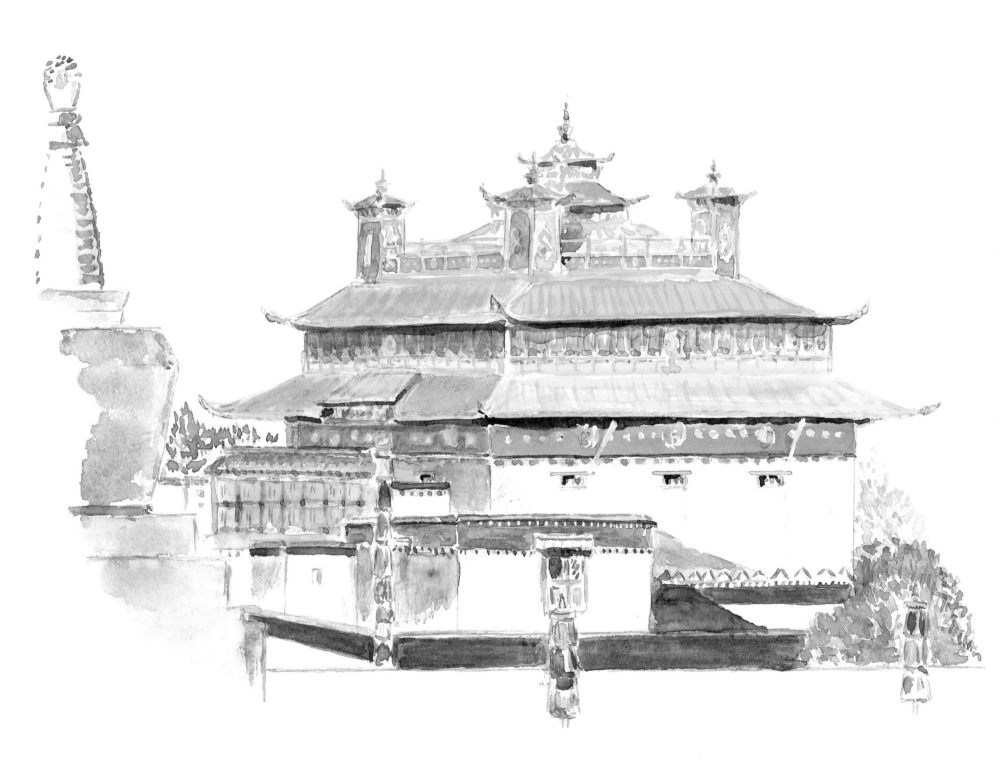

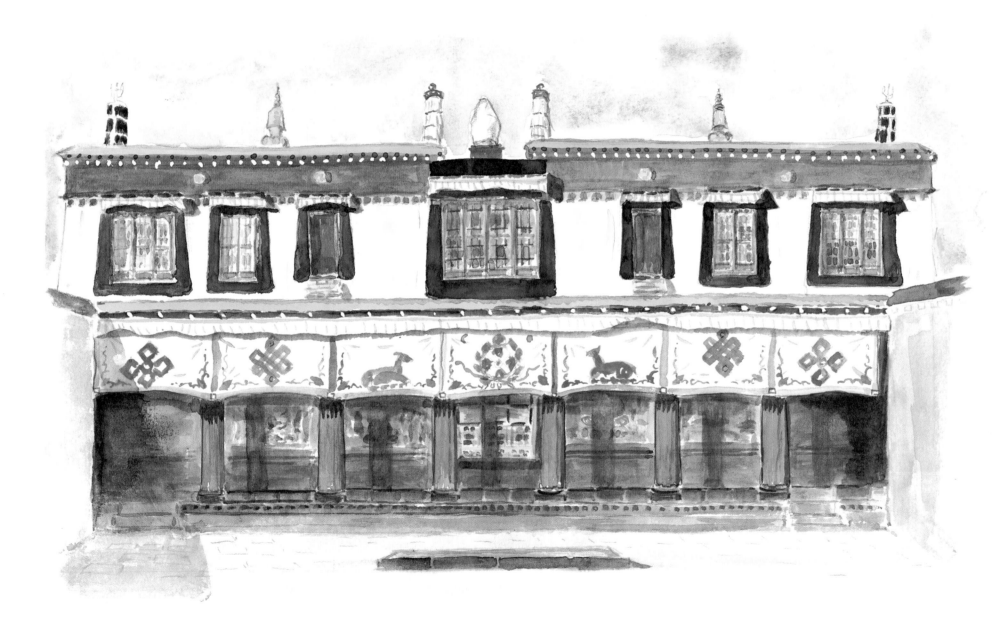

The Buddhist Revival

Drolma Lhakhang, the temple of the bodhisattva Tara,
was built in the eleventh century.

The cave monastery of Shergol.

The Buddhist revival began in the early eleventh century under Yeshe Ö, the king of Guge, a small principality in southwestern Tibet. He sent the monk Rinchen Sangpo (958–1055) and twenty others to India to study Buddhist texts and translate them into Tibetan. Upon his return to Guge, Rinchen Sangpo founded the monastery of Tholing, a fine example of early religious architecture. Like Samye, it is built in the form of a mandala, with chortens (similar to Indian stupas) marking the four cardinal points. Rinchen Sangpo also founded monasteries in Spiti, Zanskar, and Ladakh, and perhaps the cliffside hermitage of Shergol.

In 1042 Yeshe Ö brought the Indian sage Atisa (982–1072) from Bengal to Tibet. He and his followers translated the major Sanskrit works on Buddhism into Tibetan, resulting in the 108-volume Kanjur (original writings) and 225-volume Tanjur (commentaries). Atisa founded several monasteries in central Tibet, where he started the Kadam school of Buddhism. The Kadampa wanted to reform the religion, which they considered too dependent on magic.

Drolma Lhakhang, founded by Atisa, still stands in Nyethang, approximately twelve miles southwest of Lhasa. Dedicated to Drolma (called Tara in India), the popular female bodhisattva, this monastery was spared destruction by the Chinese, on the request of Bengali authorities. It is a vibrant example of the simple beauty of early Tibetan monasteries, with a long, open porch and symmetrical windows. The interior features representations of the bodhisattva Tara, who is associated with the colors white, blue, green, and red. These are among the few ancient frescoes and statues not demolished by the Chinese. The elegance of the building comes from the simple lines, delicate awnings, and subtle blend of natural pigments such as blue, black, and red ocher, along with whitewash.

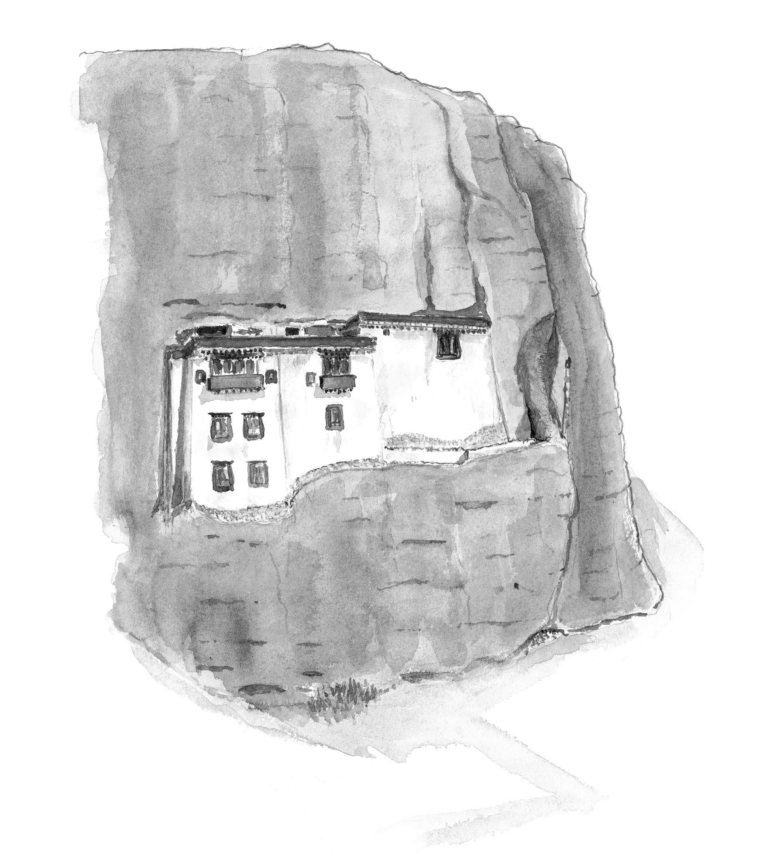

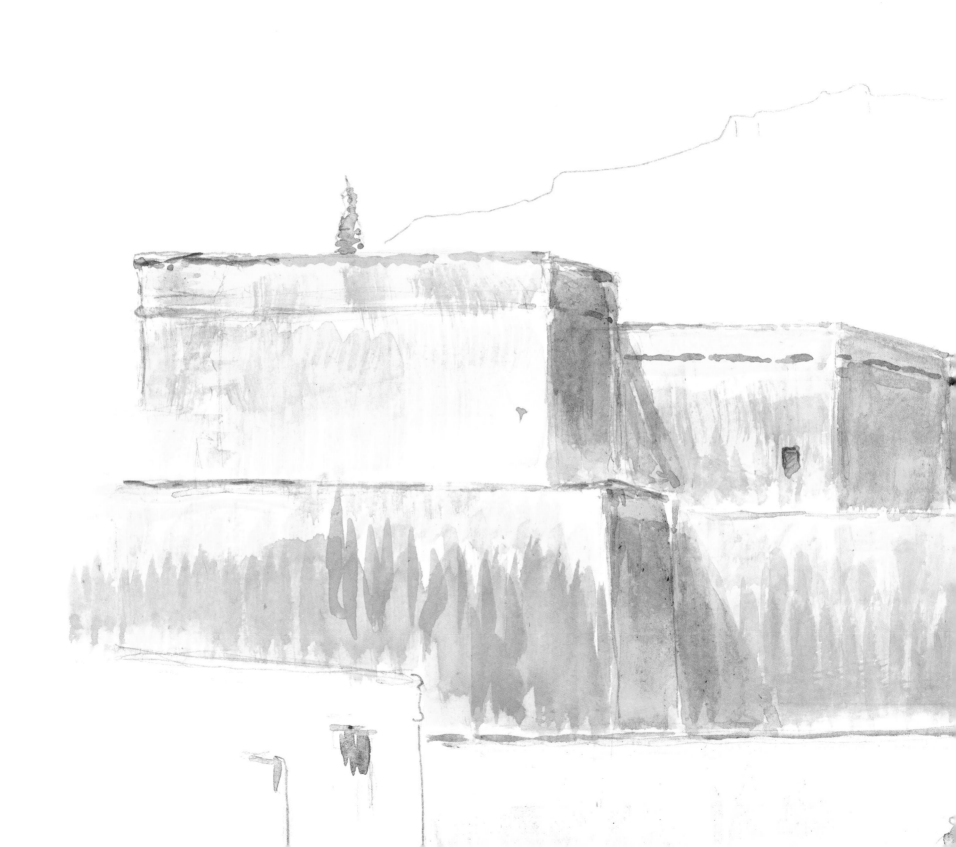

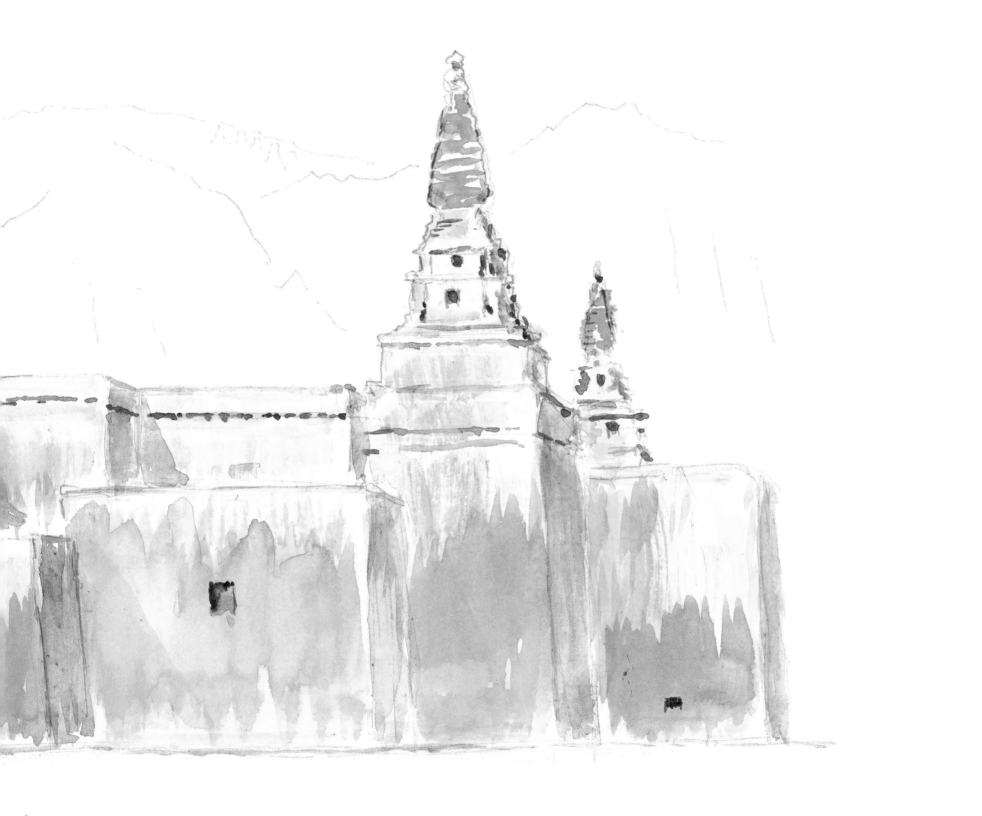

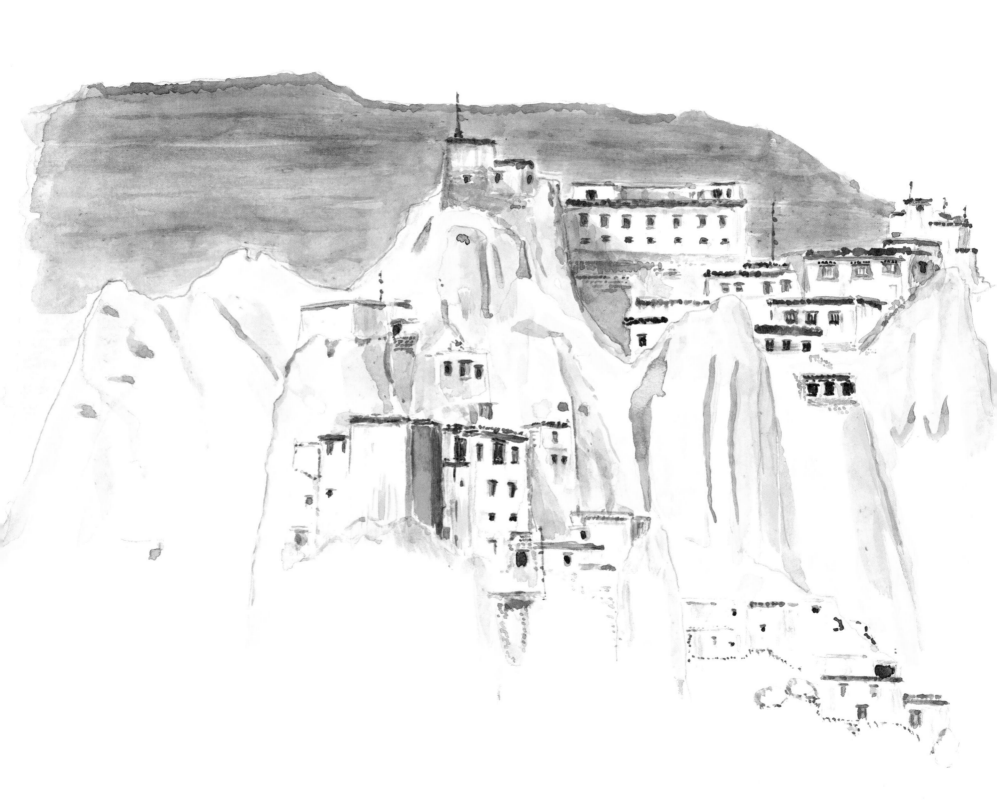

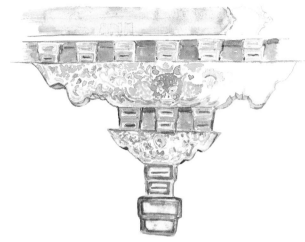

In contrast with the rest of the sober architecture, the interior columns of monasteries are decorated with elaborate baroque designs.

38 Dankhar, the cliffside capital of Spiti, welcomed the monk Rinchen Sangpo. Its monastery stands along the cliffs, as opposed to earlier monasteries, which were built in the valleys.

During the eleventh century many other Indian and Tibetan monks set up their respective schools throughout the highlands, rivaling the ancient Nyingma school established at Samye by Padmasambhava (also known as Guru Rinpoche, "precious teacher") in the eighth century. After Atisa, the most famous of these sages was Marpa (1012–1096), a Tibetan who had studied in India under the teacher Naropa. Marpa is regarded as the founder of the Kagyu order, although he was a married layperson. One of his students was the mystic poet Milarepa. To break the rebellious spirit of Milarepa and make him atone for his past sins, including the practice of black magic, Marpa commanded him to build a tower, then knock it down, and repeat this three times. The tower of Sekhar Guthok still stands, although factual history seems to show that the tower was built for defense; according to the Tibet historian Giuseppe Tucci, it was built first as a round tower, then

as a semicircular structure, and then finally in its present rectangular form. Along with Yambulagang, it is one of the few towers in Tibet that has a pagoda-like roof, most likely added after the original construction.

Another new school founded during the Buddhist revival was the Sakya order, centered at the Sakya monastery founded in 1073. In 1244, at the height of the Mongol Empire's power, the head of Sakya was invited to the Mongol court. Prince Godan was impressed by the abbot and made him the regent of Tibet. Upon the abbot's death, his nephew Phakpa (1235–1280) became the friend and advisor of Kublai Khan (1216–1294). Kublai gave Phakpa the title *Ti shih*, which made him the virtual ruler of Tibet.

The great Mongol leaders did not convert to Buddhism, but their patronage gave the Sakyapa tremendous prestige and protected Tibet at a time when the Mongols were successfully waging

The famous tower of Sekhar Guthok was built by Milarepa, the mystic poet, under the orders of his teacher, Marpa.

42–43 This massive fortified monastery, the seat of the Sakya order of Buddhism, was at one time the religious hub of the Mongol Empire.

war from Sarajevo to Indonesia, from the doors of Vienna to Japan. Today the northern portion of the Sakya monastery is a pile of rubble. However, the massive, fortress-like, rectangular southern section, built in the sixteenth century, is perfectly preserved. Twelve-foot-thick walls enclose a grand assembly hall and library containing priceless treasures: thousands of ancient porcelains; 2,000 painted scrolls; more than 20,000 books, some of which date back to the tenth century; precious objects such as giant elephant tusks; and the 800-year-old edict proclaiming Phakpa the overseer of Tibetan affairs with the seal of Kublai Khan.

Buddhism became much more popular with the nobles during this period than when first introduced. The daily governance of Tibet was still run by local royal families, and the principalities of Tibet continued to prosper. The population was stable, and farmers were rich and could well afford to subsidize the religious

studies of their younger brothers at monasteries, which were more like schools and universities than Christian cloisters. Monks had a great deal of freedom to study what they pleased; if they were not financially supported by their families, they could work in the service of richer monks. Monasteries were enlarged to accommodate more monks, and donations paid for gold-plated statues, elaborate frescoes, and expensive silk hangings. Family fortresses were transformed into palaces, and homesteads became manor-like farmhouses with a private chapel, library, and adjacent house where the parents retired after the marriage of their son.

Protected from invasion by the Mongols, Tibet grew into a rich enclave within Asia. Marriage among the nobles of the realm cemented alliances between the various regional lords, who left each other in peace. Despite the difficulties of the rugged terrain and harsh climate, famine did not plague Tibet as it did India and

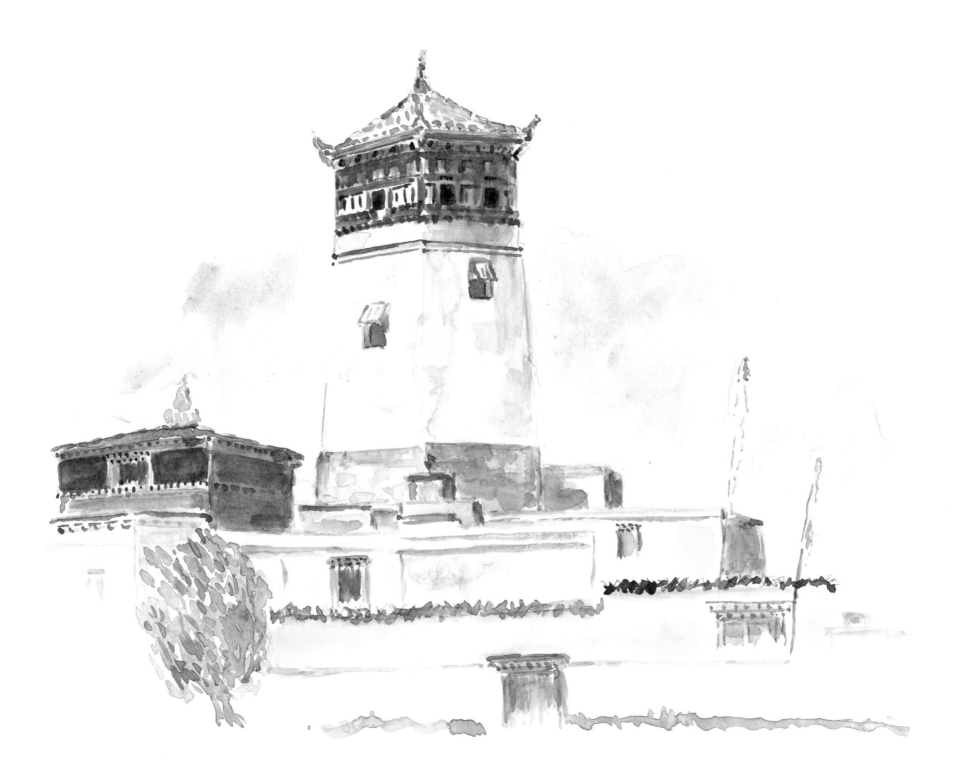

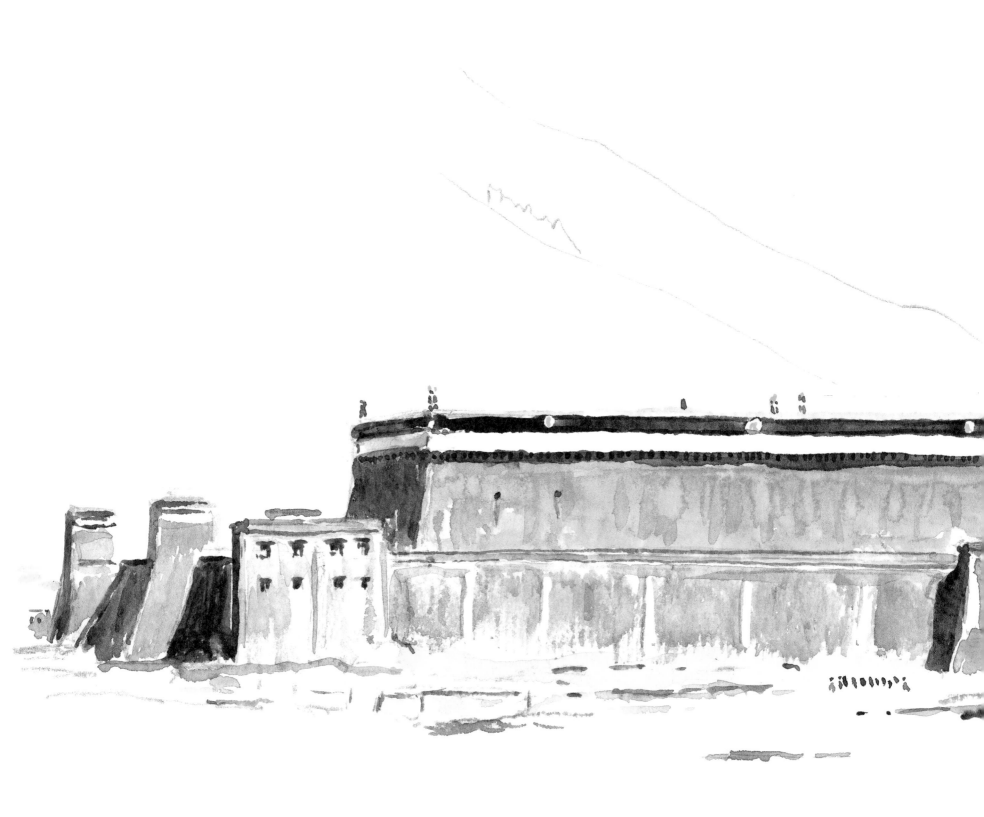

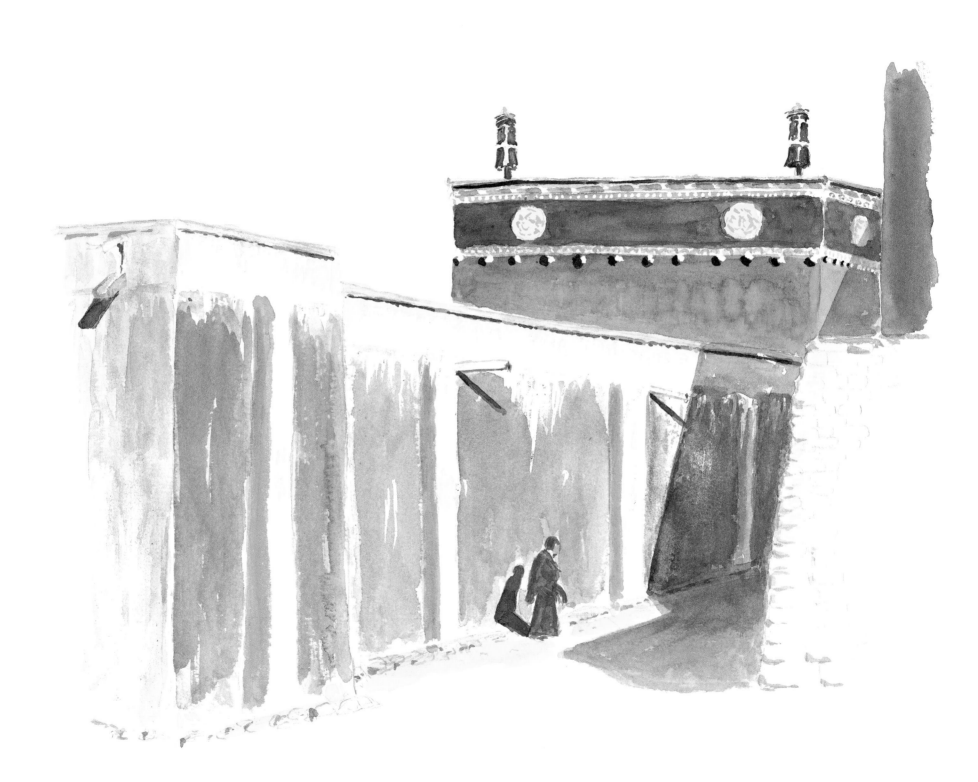

The Sakya monastery of Jeykundo caters to the nomads of southern Amdo.

China. Population control was fostered by the celibacy of monks and the practice of fraternal polyandry (brothers shared wives). In addition, in the high, dry air grain can be stored for decades, and reserves were large enough to overcome the consequences of crop failure. The nomads maintained very large herds, which helped them to survive if severe hailstorms caused the death of a great number of their animals.

The nomads of southern Amdo patronized the monastery of Jeykundo, of the Sakya order, as identified by its blue-gray, red, and white stripes. This important monastery dominates the crossroads of trails linking Lhasa and eastern Tibet with the northern provinces and the Silk Road.

In 1964 I traveled to Lo Monthang, the amazing walled capital of Mustang. I had the honor of meeting the king, who told me that the realm was founded in 1480 by a prince named Ame Pal.

This prince had invited the famed Sakya reformer Ngorchen Kunga Sangpo to Mustang, where he consecrated a monastery. All but two of the dozen monasteries in Mustang belong to the Sakyapa; the monastic architecture echoes the great walls of Lo Monthang.

I was the first foreigner to reside at length in the kingdom of Lo, as Mustang is called in Tibetan. (*sMonthang* means "plain of prayer"; the British later corrupted the word to *Mustang*.) During my stay I found a manuscript that confirmed that Mustang had been an independent Tibetan principality for 500 years, a fact unknown even to Giuseppe Tucci, the great scholar of Tibetan art, religion, and history. Tucci had rushed through Mustang two years before on his way to western Nepal, where he was studying the origins of the Malla kings; he mistakenly believed that Mustang was part of an adjacent region. I thus had the privilege of reveal-

The stripes of the forbidding walls of the great assembly hall of Tsarang proclaim its affiliation with the Sakya order.

48–49 Lo Monthang, the capital of the kingdom of Lo (Mustang), was fortified toward the end of the fifteenth century. In 1964, when I stayed here, the gate into the city was closed every night at eight to guard against robbers.

ing the true identity of this minute, forgotten kingdom in my doctoral thesis.

I was amazed to find that Mustang was still ruled according to the customs and laws introduced by Songtsen Gampo in the seventh century. Land could not be bought or sold and was handed down from father to son when the latter married; all of the plots of land were more or less equal in size. The king was not involved with the administration of the villages and towns, which were governed by elected councils. As in ancient Tibet, Mustang had three separate administrations and three courts of justice: the village court, the religious court, and the king's court. The king was only in command of defense and relations with the other Tibetan rulers. The twelve noble families levied land taxes on the farmers, and the nobles supplied the king with accountants, historians, generals, and chamberlains. In exchange, the nobles received privileges such as the right to wear blue gowns, own a castle or a three-story house within the city walls, sit at the king's table, and marry his daughters. Yet the nobles owned no more land than a typical household. The king himself customarily married a woman from the Tibetan aristocracy outside of Mustang.

This insight into Tibet's ancient past helped me to better appreciate the force and originality of Tibetan culture and to comprehend the great extent to which the rule of the Dalai Lamas had modified the traditional Tibetan way of life. By seizing the land of farmers and aristocrats, the Dalai Lamas created vast religious estates, which reduced many peasants to the role of serf—the very fate that the Tibetan founding fathers had wished to spare their subjects. I later found that Baltistan, Ladakh, Zanskar, and much of eastern Tibet also maintain many of these ancient customs, although to a lesser degree than Mustang.

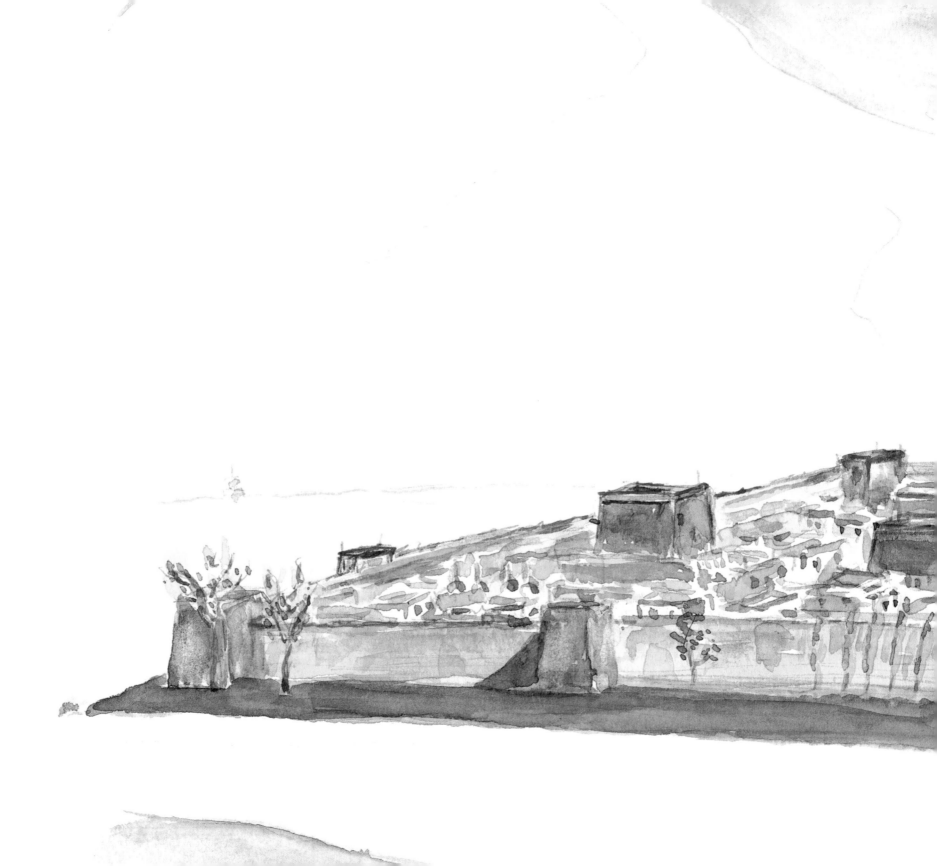

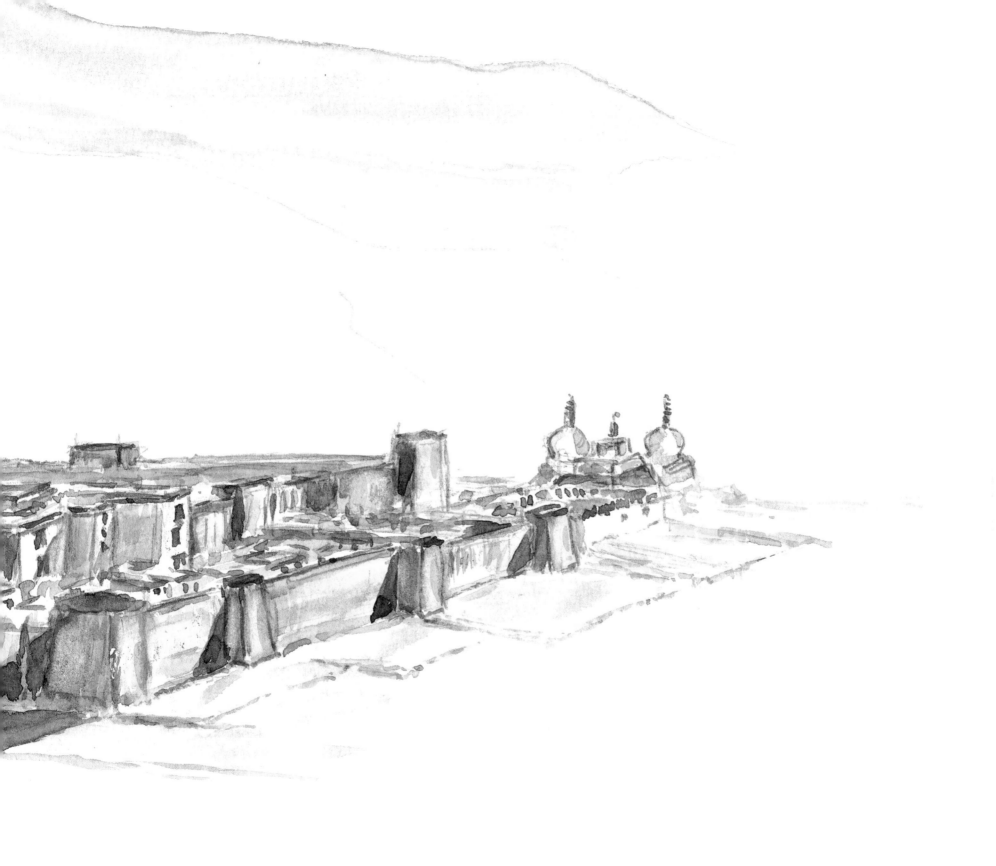

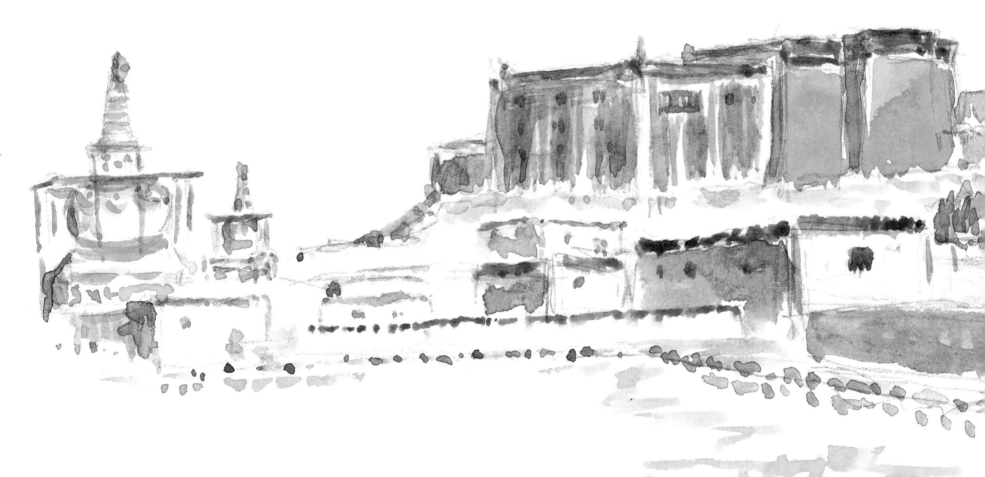

I was most impressed by the elegance of the chortens in Mustang, in particular the door chorten leading to the town of Tsarang and the cluster of chortens of Yara. Chortens are found everywhere in the Tibetan world: at the tops of passes, at the entrances of villages, at the corners of buildings where demons lurk, and on the altars of monasteries. Originally copied from the Indian stupas, which are primarily funerary mounds, the chortens in Tibet took on a variety of shapes and meanings. A chorten is like a small temple; the word *chorten* is best translated as a support or receptacle of the faith. Some chortens contain the body of a deceased saintly monk or *tsa-tsa*, small figurines of Buddha and bodhisattvas made of clay mixed with the ashes of lamas or loved ones. They can also contain books, manuscripts, or fragments of manuscripts too precious to be thrown away.

Chortens symbolize the enlightenment of the Buddha, similar to mandalas, with different shapes symbolizing the elements and nirvana. There are eight types of chortens, but only two or three are common in Tibet, including the "chorten of illumination" described by Tucci. This has a square base with steps leading to a circular drum, crested by parasols, figures of the sun and moon, and a flame. To build or restore a chorten is a deed of great merit, as is walking around a chorten in a clockwise direction.

Mustang's monasteries have remained practically untouched since their foundation in the early sixteenth century. The walls of the main assembly hall in the heart of Lo Monthang are covered with outstanding 400-year-old paintings of mandalas. These masterpieces of Tibetan art, along with the frescoes in the Maitreya temple of the Champa monastery, are now undergoing restoration with the help of funding from the American Himalayan Foundation.

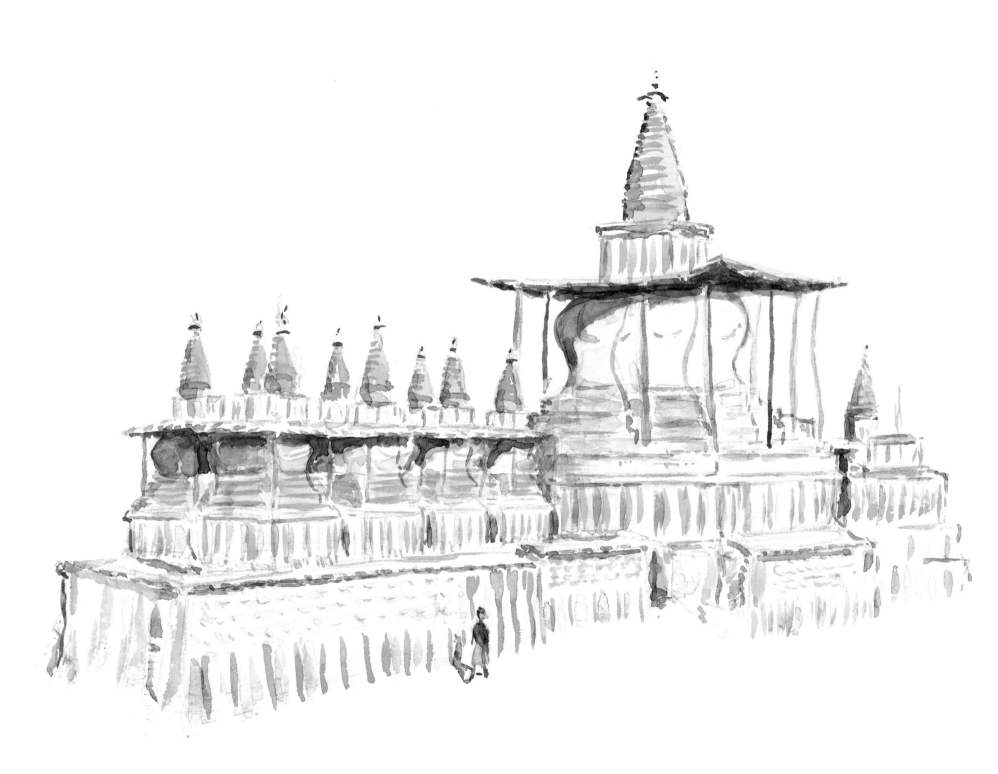

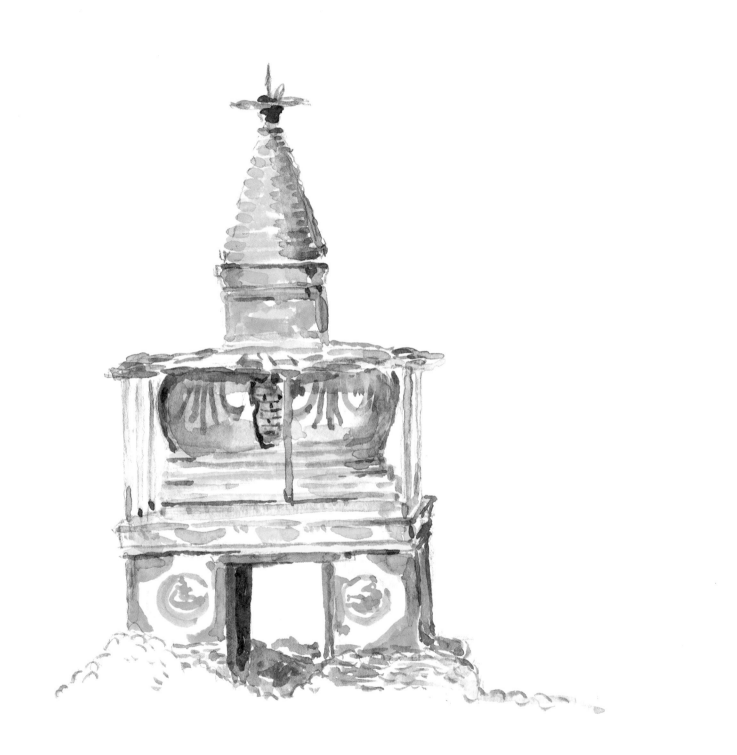

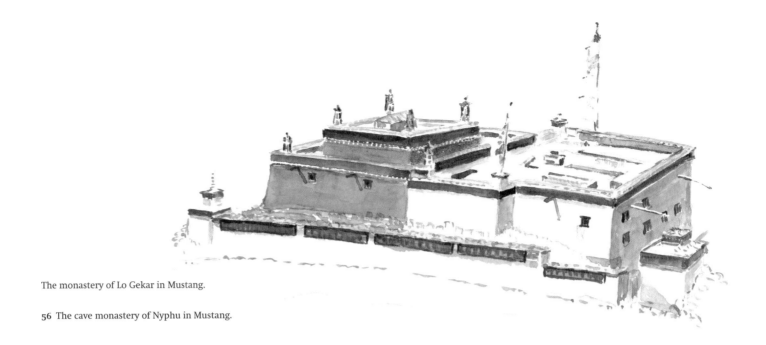

The monastery of Lo Gekar in Mustang.

56 The cave monastery of Nyphu in Mustang.

Lo Gekar is a remarkable monastery set in a lonely valley of the small kingdom. It is a perfect example of early Tibetan temples built during the revival of Buddhism. Modest in size, the temple has a central assembly hall encircled by a covered passageway, allowing pilgrims to circumambulate the shrine. The hall, lit by a skylight, holds the altar, with holy images of lamas and incarnations of the Buddha's virtues. The temple also contains a small apartment and a few cells to house the lama and his pupils. The monastery is surrounded by niches containing prayer wheels, cylinders filled with printed religious texts that are spun while one is walking around the building. The harmonious proportions and sloping walls lead the eye to the decorative frieze bordering the flat roof.

Dozens of prehistoric cave cities are found in Mustang, hollowed out of the sandy cliffs. In later times monks retired to the caves to meditate. Several monasteries were built into the cliffs, including Nyphu. The monks' cells are ancient smoke-blackened chambers that once provided winter shelter for hunters and herders; the assembly hall was dug out of the cliff face and sealed by a masonry wall. Many monasteries in Tibet are built in or around caves, serving as a reminder that the early teachers of Bon and tantric Buddhism were often hermits, and their pupils settled close to their retreats.

One famous cave is the Bon monastery of Gurugem in Ngari, not far from the presumed location of the ancient capital of Zhang Zhung, the Bon federation of Tibetan tribes. Regions remain today that do not accept Buddhism because they consider it an alien religion; in particular, near Denchen in northeastern Tibet, the ancient Bon beliefs are prevalent.

The most spectacular of all the cave monasteries I have seen is

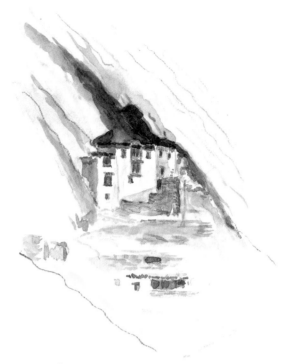

The Indian sage Naropa is said to have stayed in the cave monastery of Zongkhul, in Zanskar. Naropa was the teacher of Marpa and Rinchen Sangpo.

59 The chapels and assembly halls of Phuktal monastery are carved out of the cliff.

Phuktal, located in a high, isolated valley in Zanskar. It is set deep within a cave so vast that it contains several assembly halls. The cells of the monks tumble out of the immense cavern like a waterfall of rectangular blocks. In 1824 Alexander Csoma de Koros, the Hungarian scholar who became the father of Tibetan studies, resided here for a year. In Ladakh he had met William Moorcroft, the British adventurer, who advised him to study the Tibetan language. Moorcroft introduced him to a scholarly monk from the royal family of Zangla, a minute principality within the kingdom of Zanskar.

For a year de Koros stayed in the dilapidated and windy clifftop castle of the kings of Zangla, where he practically froze to death as he learned to read and write Tibetan. He wrote one of the very first Tibetan dictionaries—the very first was a Latin-Tibetan dictionary compiled by Capuchin friars in the early eighteenth century, after setting up a mission in Lhasa. After his stay in Zanskar, de Koros spent the rest of his life in the Indian Himalayas, studying Tibetan texts. He planned a journey to Lhasa, but died of a fever in Darjeeling in 1842, on his way to the holy capital.

Zanskar has another famous cave monastery, Zongkhul, which is said to have been the refuge of the Indian sage Naropa. His most famous pupil was Rinchen Sangpo, who mastered all of the Buddhist teachings during seventeen years in India. The Great Translator, as Rinchen Sangpo was called, founded the monastery of Nyarma in Ladakh, now in ruins. His patron, the king of Guge, Yeshe Ö, was also the ruler of Zanskar at that time.

Most of the monasteries in Ladakh date from the Buddhist revival of the eleventh century and after. Earlier structures include the cave monastery of Shergol and the magnificent monastery of Lamayuru, which was strategically located along the trade route

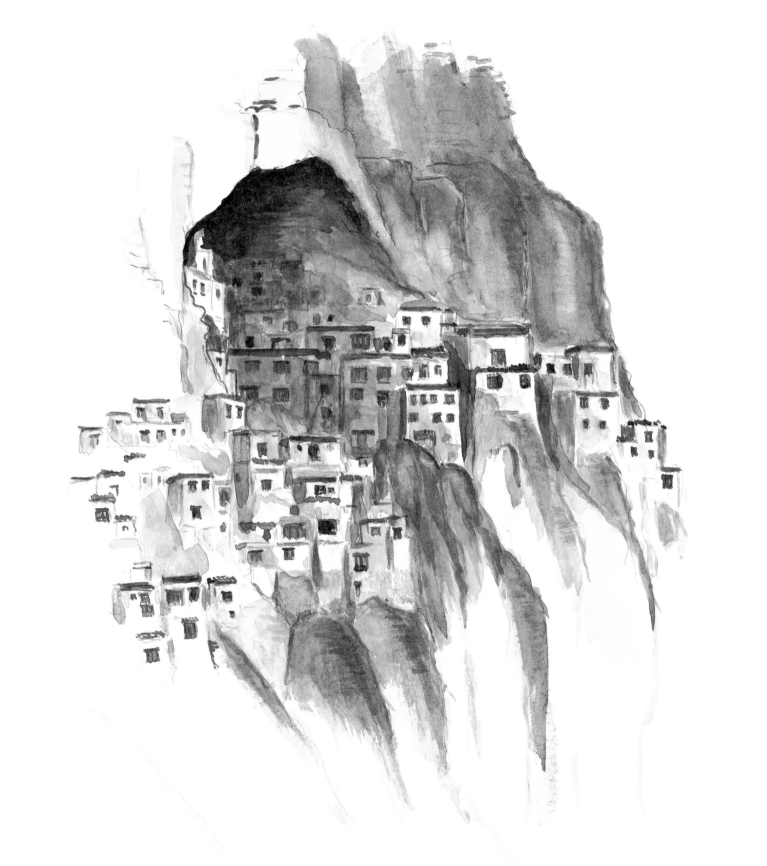

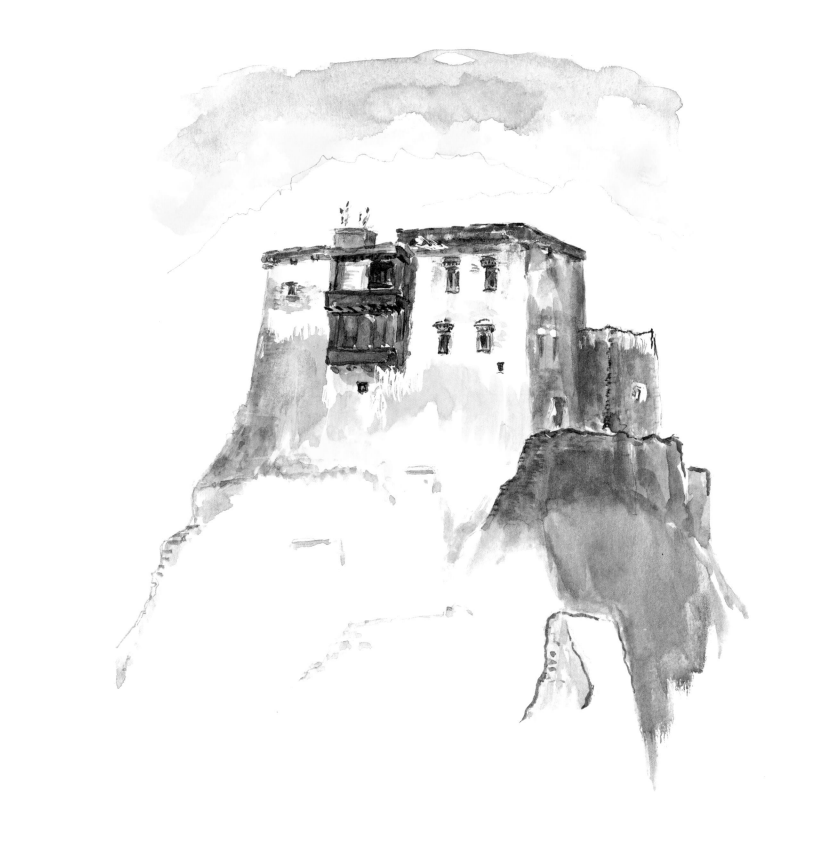

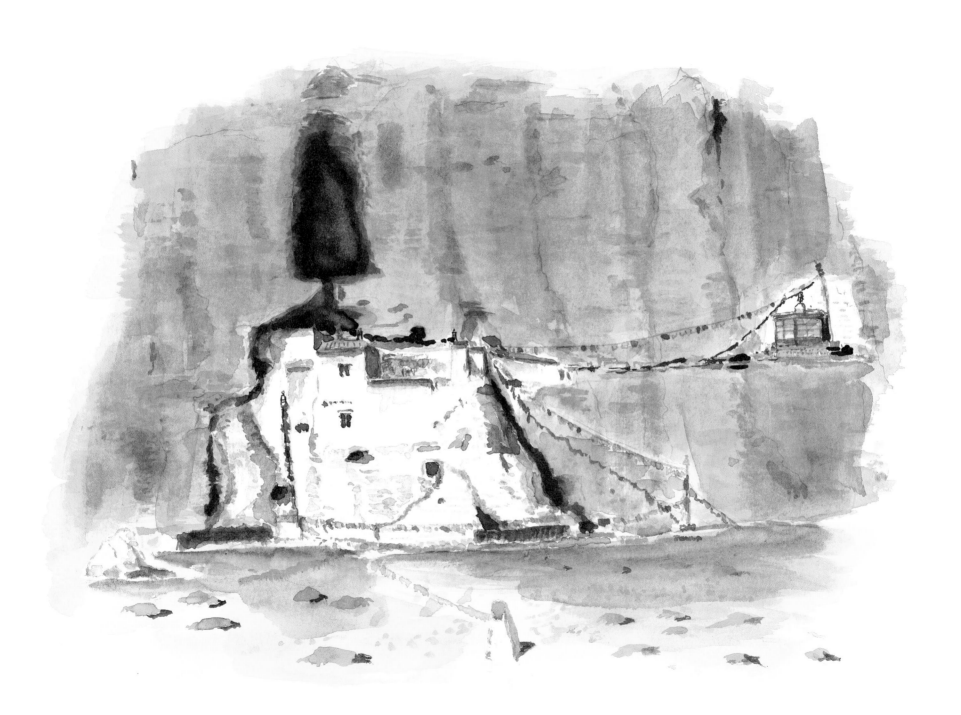

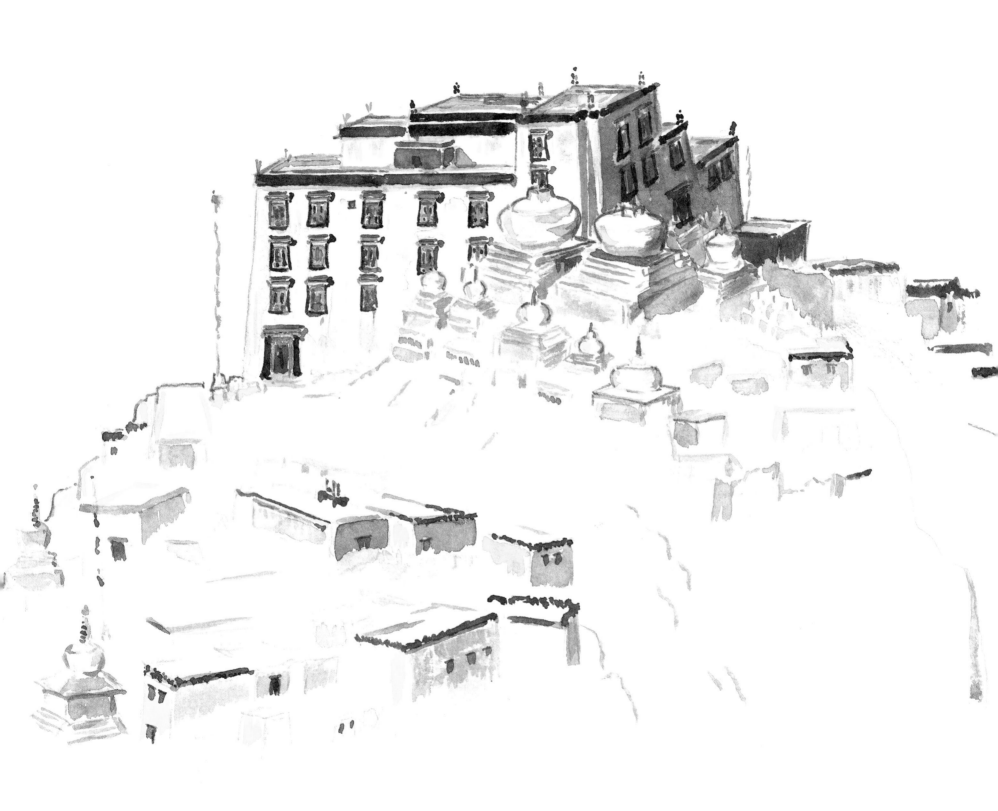

60 Zangla Dzong is the ancient, wind-beaten, royal castle of the minute principality of Zangla, in northern Zanskar.

61 The Bon cave monastery of Gurugem in western Tibet lies close to where historians believe the lost capital of Zhang Zhung stood.

The ancient monastery of Lamayuru holds a key position along the trade route linking Tibet with Kashmir and ultimately Persia.

following the upper Indus River. Situated halfway along the trail linking Srinagar, the capital of Kashmir, with Leh, the capital of what was eastern Tibet and then Ladakh, Lamayuru is one of the oldest and most important monasteries of Purig, a region inhabited by the Indo-European Minaro people. Within the monastery precinct stands a Bon chapel, which reveals that this was a pre-Buddhist shrine. The Minaro are Buddhist, but they have retained their ancient faith in a goddess of fertility and fortune, whom they still invoke for success in the hunt and during childbirth. Situated on a spur built over caves that must have sheltered Neolithic hunters, this fortified monastery stands guard over central Ladakh.

The journey from Lhasa to Leh would take the slow-traveling caravans three to six months. Every dawn the travelers spent hours rounding up their animals, feeding the yaks, and saddling

and loading the pack ponies; later in the day more time was lost when the donkeys and horses needed to graze. At night the caravans stopped at hamlets or caves or sought shelter at the foot of an overhanging cliff.

Forts were numerous in Ladakh, as each king traditionally built his own upon taking the throne. To the east of Lamayuru lie the ruins of the fourteenth-century palace-fortress of Temisgam (Tingmogang), where a red chapel houses a magnificent image of Maitreya, the future Buddha, the successor to the historical Buddha. A statue of Maitreya also occupies three floors of the Champa temple in Lo Monthang; Champa is the Tibetan name for Maitreya. These often gigantic, awe-inspiring statues are found throughout Tibet.

Two thousand miles to the east, along the borders of Chinese Sichuan in Kham, the independent Khampa tribesmen were busy

These elegant and vast five-storied farmhouses stand beside the ruins of towers in the rich valley of Danba, in eastern Tibet.

66 A lone tower in Kham.

67 Erected nearly eight hundred years ago, these star-shaped twin towers of Remede have survived many earthquakes.

building huge freestanding towers that proclaimed their wealth and arrogance. The origins of this style of construction are a mystery. Some stand within the compound of a manor and thus might have served as lookouts for defense, but others rise close to each other. There is almost a tower to every homestead, with some 160 towers in the village of Danba alone. The tallest towers are a staggering 200 feet high. The most remarkable are the twin towers of Remede. Carbon-dating tests initiated by Frédérique Darragon revealed that the wood from most of the towers was five to six hundred years old, but one structure in Kongpo dates back more than 1,000 years. At the beginning of the last century, the Kongpo region alone was home to 200 towers, described by the botanist Frank Kingdon Ward; today barely a dozen remain. These towers are among the many marvels of Tibetan architecture.

The prominence of the Sakya monks came to an end with the eclipse of the Mongol emperors of China, the Yuan dynasty, in 1368. Tibet was again ruled by royal families; one branch governed western Tibet, another governed the east, and a third oversaw the central provinces of U and Tsang. The fifteenth century marked the beginning of the golden age of Tibetan architecture, as the monasteries increased in wealth, size, and number, at the expense of the palaces and forts.

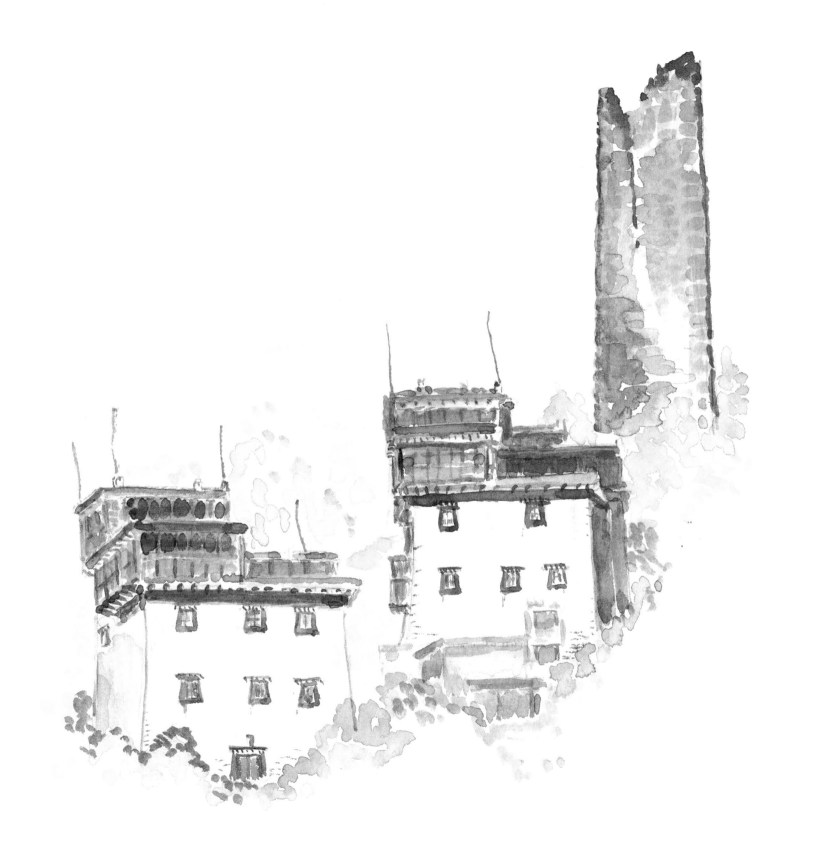

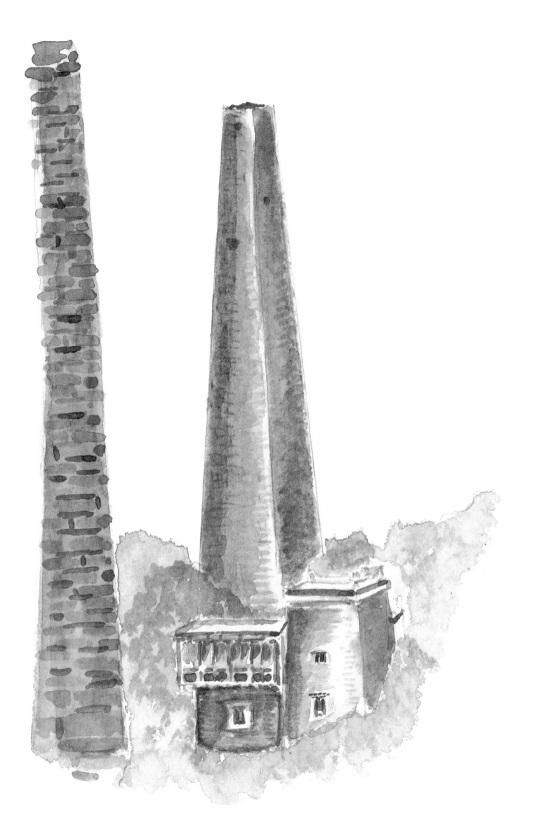

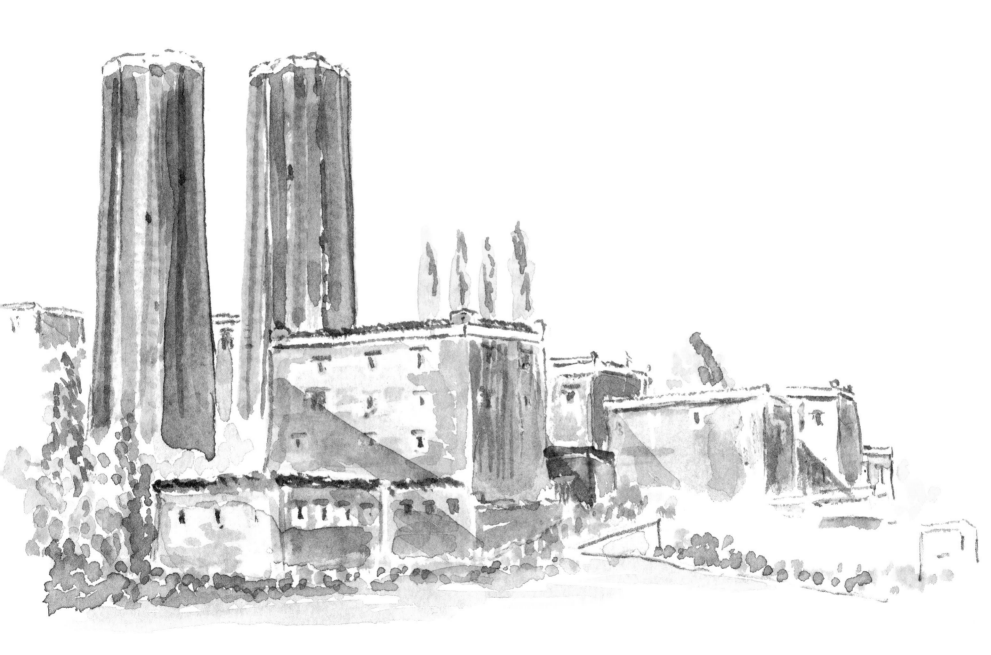

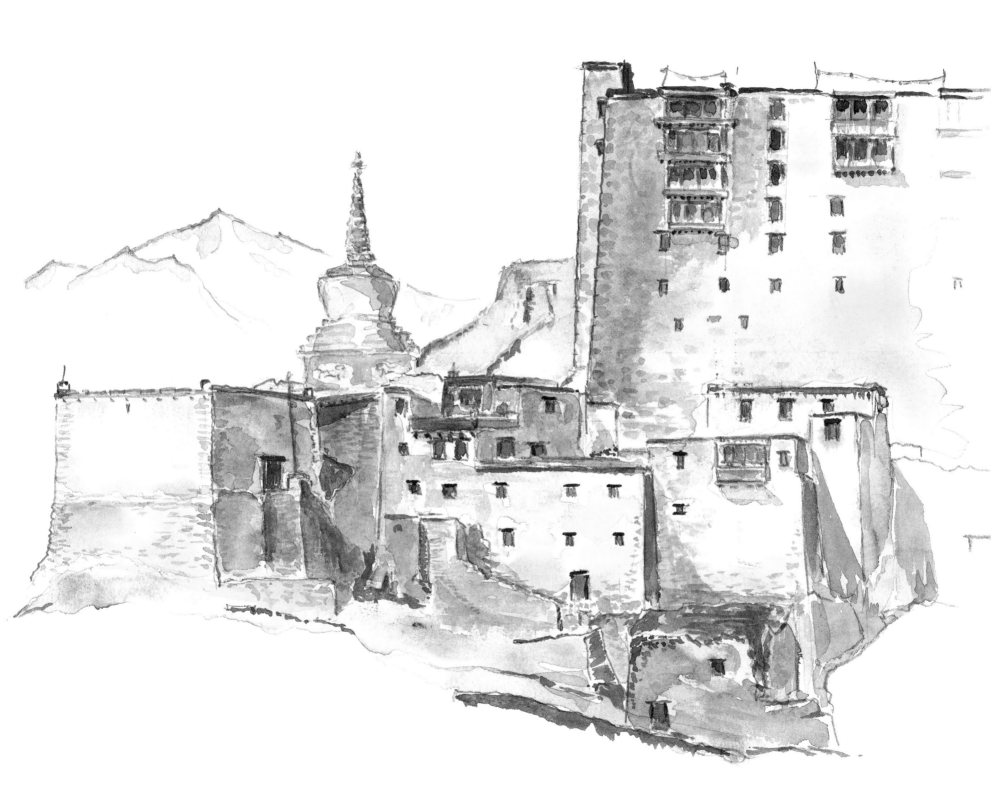

The Golden Age of Tibet

The great palace-fortress of Senge Namgyal in Leh,
the present capital of Ladakh.

A large manorlike farmhouse near Mulbek, in Ladakh.

72 A large farm in Minyak proclaims the wealth of the fiercely independent Khampa tribesmen.

73 The hilltop royal fortress of King Tashi Namgyal overlooks the Indus River near Leh.

During my travels I was constantly impressed by the size of the farmers' homes, in Ladakh, Bhutan, and eastern Tibet, in particular. Many are true mansions, illustrating how the clever management of limited resources can lead to a stable, prosperous society. Survival at such a high altitude requires careful planning. In most of Tibet the only available fuel is yak dung, and cultivable land and water for irrigation are scarce. The season for growing crops is very short, and grasslands are so poor that it takes several acres to feed one head of cattle. Yet by the fifteenth century Tibet was rich enough for a third of the male population to devote their lives to scholarly pursuits, and the country had one of the world's highest literacy rates. The monks began to have political ambitions, and their opinions came to have as much weight as those of the local lords.

The nobles abandoned their hilltop forts in favor of lower, more accessible fortified palaces. The monasteries, formerly simple, low-lying chapels, took the place of the abandoned forts. The ancient hilltop palace-fortress of the sixteenth-century king Tashi Namgyal dominates Leh, the capital of Ladakh. This king fought back attacks from the new Muslim leaders of Kashmir and reestablished his family's rule over most of western Tibet. In his honor all the kings of Ladakh after him bore the name of Namgyal. Below the palace stands the Gon-khang, a temple to the fierce guardian divinities. Farther below lies the new palace of the kings of Ladakh, one of many majestic residences built over the years by the kings of western Tibet. These buildings illustrate the remarkable ability of Tibetan architects to merge their structures with the landscape.

The wealth of Ladakh is explained by its strategic geographical position as the hub of Asia. Trade routes linking India with

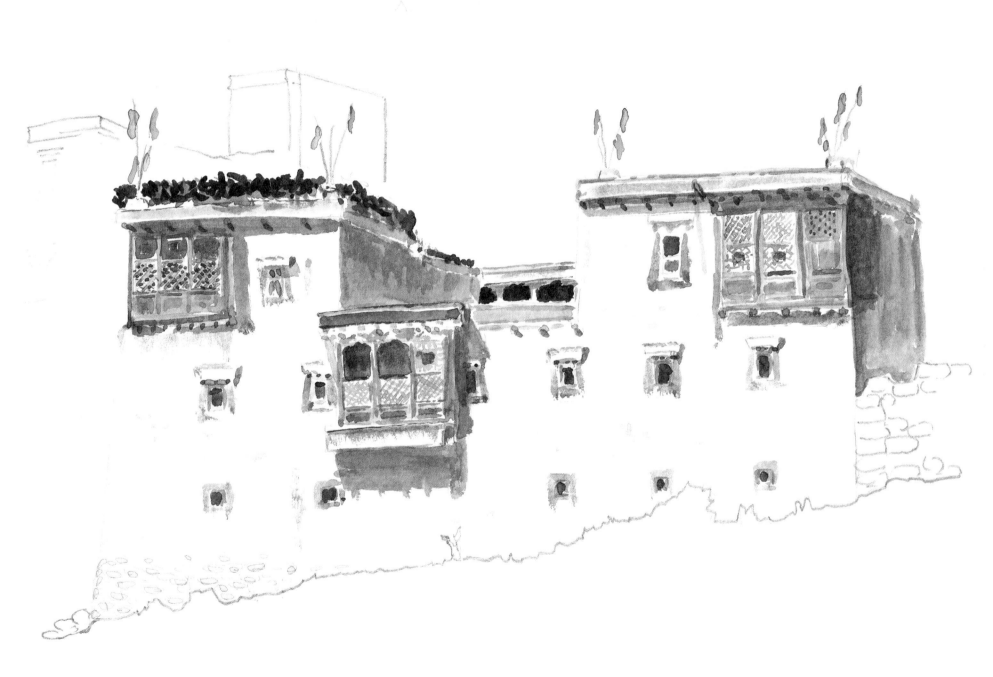

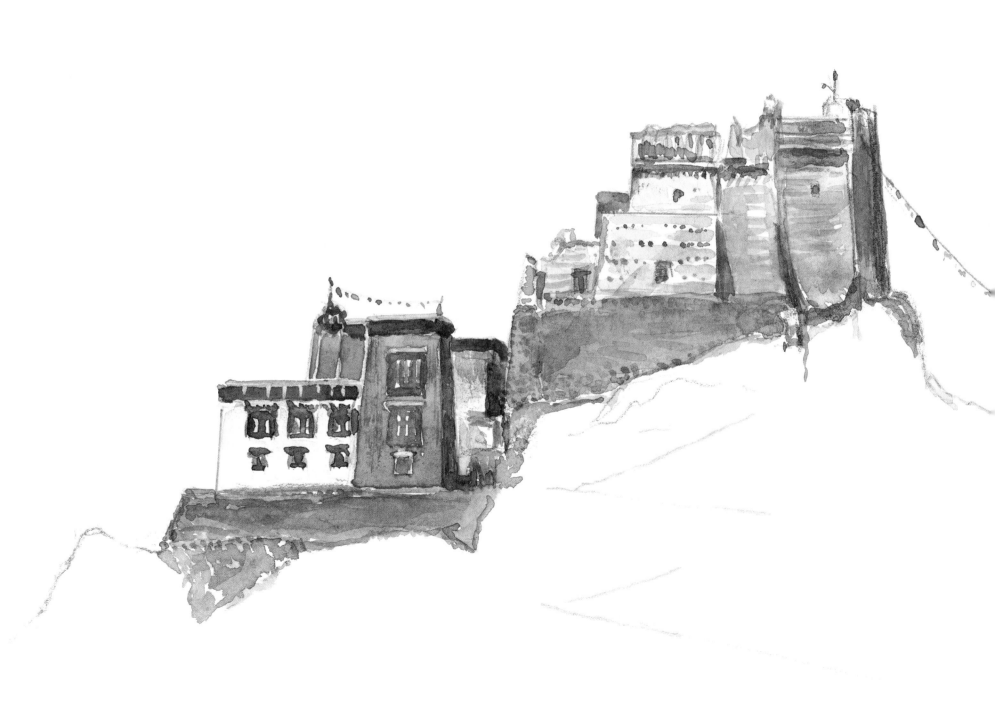

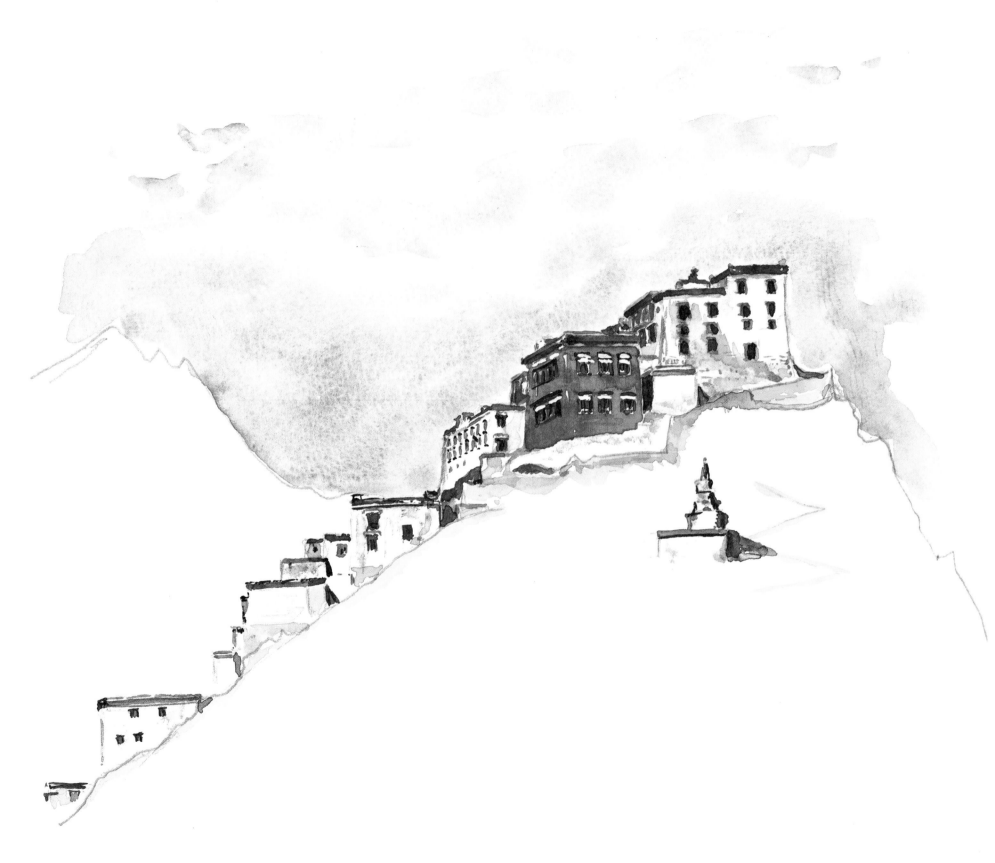

76 Stok palace is the present residence of the heirs to the throne of Ladakh.

Tikse is one of many monasteries that took over strategic positions atop crags, where palace-fortresses once stood.

77 Stakna monastery, along the Indus close to Leh, belongs to the Druk Kagyu order.

Europe, the Middle East, Mongolia, and China all crossed Tibet, most passing through Leh. Night after night, for centuries, the town's polo field at the foot of the royal palace was tied with hundreds of Bactrian camels on their way to Turkestan and Mongolia by way of the Karakoram Pass, yaks on their way from Lhasa and beyond, and mules and ponies bound for Kashmir and India.

rTa-polo, translated as "horse ball," was the national game of Tibet as early as the sixth century, and the Tibetans brought the game to the Chinese royal court. The monks later discouraged it, and today polo is only played in Ladakh, Baltistan, and Gilgit, where the British first saw the game in 1857. The British military soon adopted the game, with its Tibetan name and most of its rules intact, and polo spread worldwide.

The rich and powerful kings of western Tibet, which included the kingdoms of Guge, Ngari, Ladakh, Baltistan, Zanskar, Spiti,

Lahaul, and Kulu, were able for a while to fend off the Mughal Muslims who had invaded Kashmir and India. The Mughal Empire, established in 1525, swept away all remaining traces of Buddhism in India, leaving Tibet and central Nepal alone to carry on the Indian Buddhist traditions. Monasteries flourished, such as Tikse, a true fortress that anticipated the mightiest of all buildings in Tibet, soon to be built by the fearsome Fifth Dalai Lama: the Potala.

Tikse today belongs to the Geluk sect of the Dalai Lama, but it did not begin that way. Traditionally, the kings of western Tibet favored the Druk Kagyu order. In the seventeenth century, attempting to gain control of all Tibet, the Fifth Dalai Lama had the legitimate king of central Tibet murdered, declared war upon the ruling family of western Tibet, and fought the powerful Druk school, which had strong support not only in the western region but also in the southeast (in what is now Bhutan). The king of

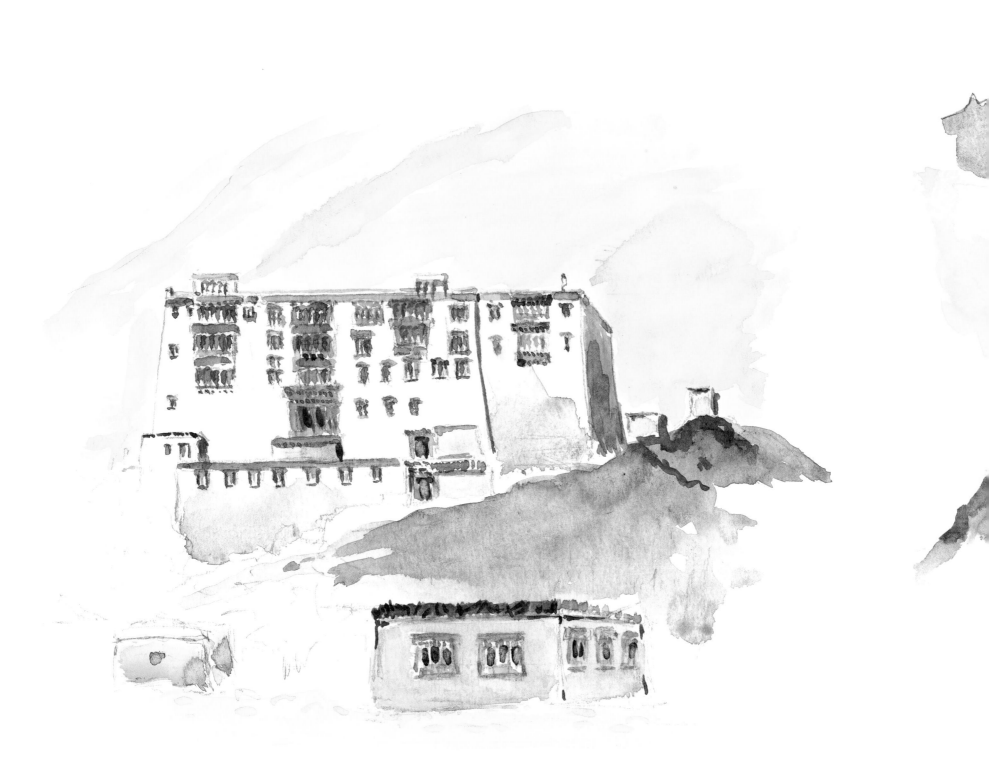

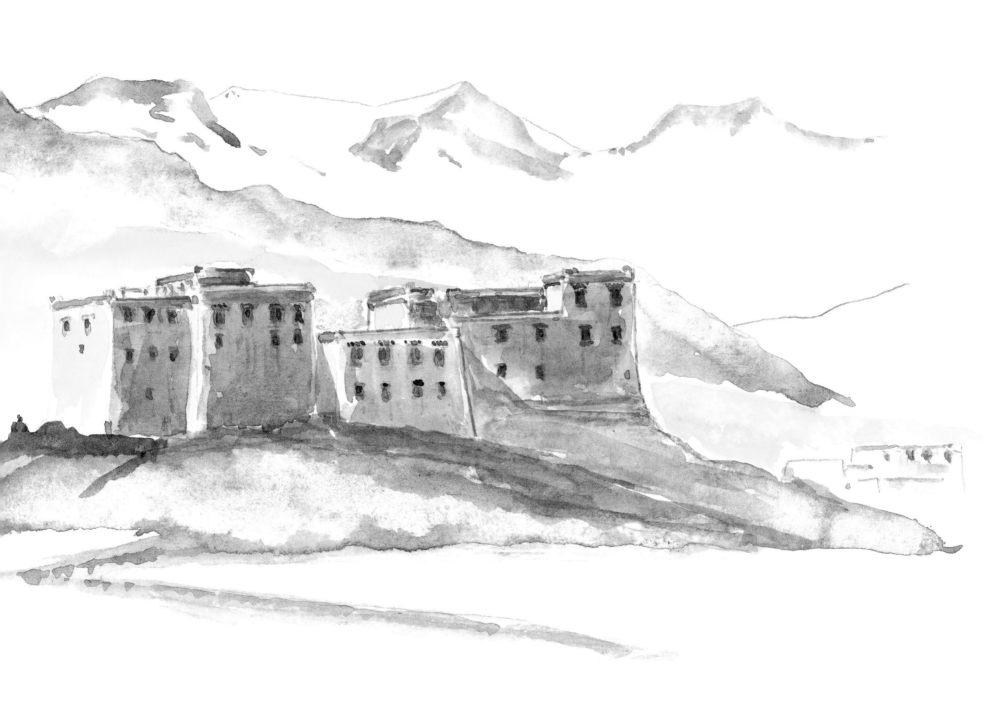

(LEFT) A rectangular door chorten in northern Mustang.

(RIGHT) The great chorten of Hemis monastery.

western Tibet eventually lost the grasslands of Ngari and the kingdom of Guge to the Dalai Lama's government. As a result of the civil wars caused by the Dalai Lama, western Tibet had no support against the Mughal conquerors. They invaded Ladakh several times, eventually converting the far western province, Baltistan, to Islam.

In 1838 Ladakh and Zanskar were invaded from the south by the Hindu warlord Zorawar Singh, a lieutenant of the Maharaja of Jammu, a small state south of the Himalayas. Zorawar Singh next attacked the Dalai Lama's troops in Guge, where he was defeated and killed. On learning that the Maharaja of Jammu had lost his army, the British moved their troops into Jammu and offered to set up the Hindu Maharaja as the ruler of rich neighboring Muslim Kashmir. In 1846 the British created the Indian state of Jammu and Kashmir, which included Ladakh and Zanskar, and

the kings of western Tibet became vassals of the British Crown. More than a century and a half later, continual religious and political conflicts between Hindus and Muslims still wrack the region, split today between India and Pakistan, with each holding a portion of ancient Ladakh.

Upon the arrival of the British, the king of Ladakh abandoned his fort in Leh and retired to his summer palace in Stok, where his descendants still live today. Because of the conflict in the region, trade through Ladakh came to a standstill, and the region went into decline. The many monasteries were impoverished but survived. More than twenty large monasteries still stand along the Indus, their approach marked by chortens, such as the great chorten of Hemis monastery. Most of the monasteries crown the bluffs, like the monastery of Matho, the only Sakya monastery in the region. The monks of Matho are known for "flying" while

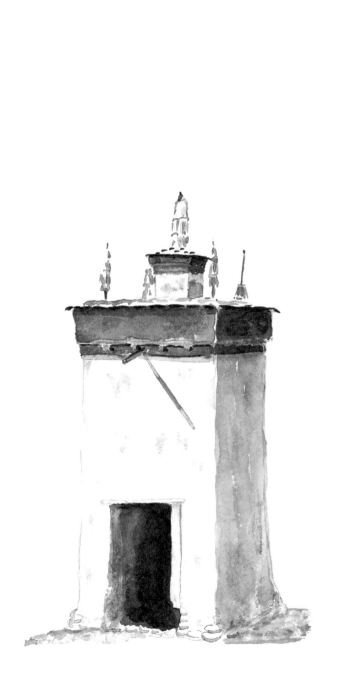

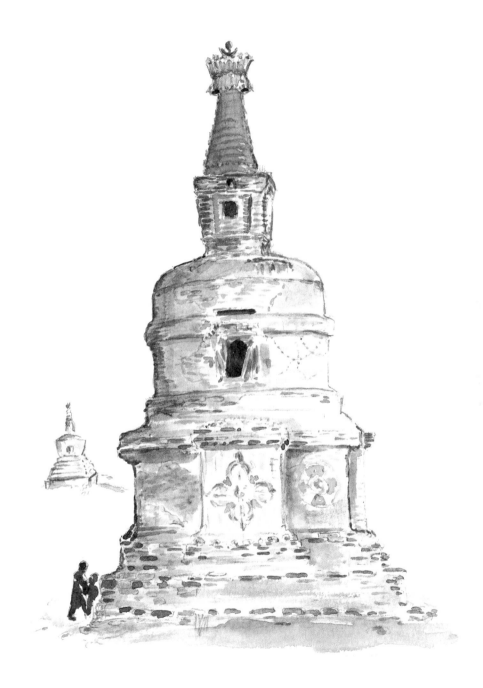

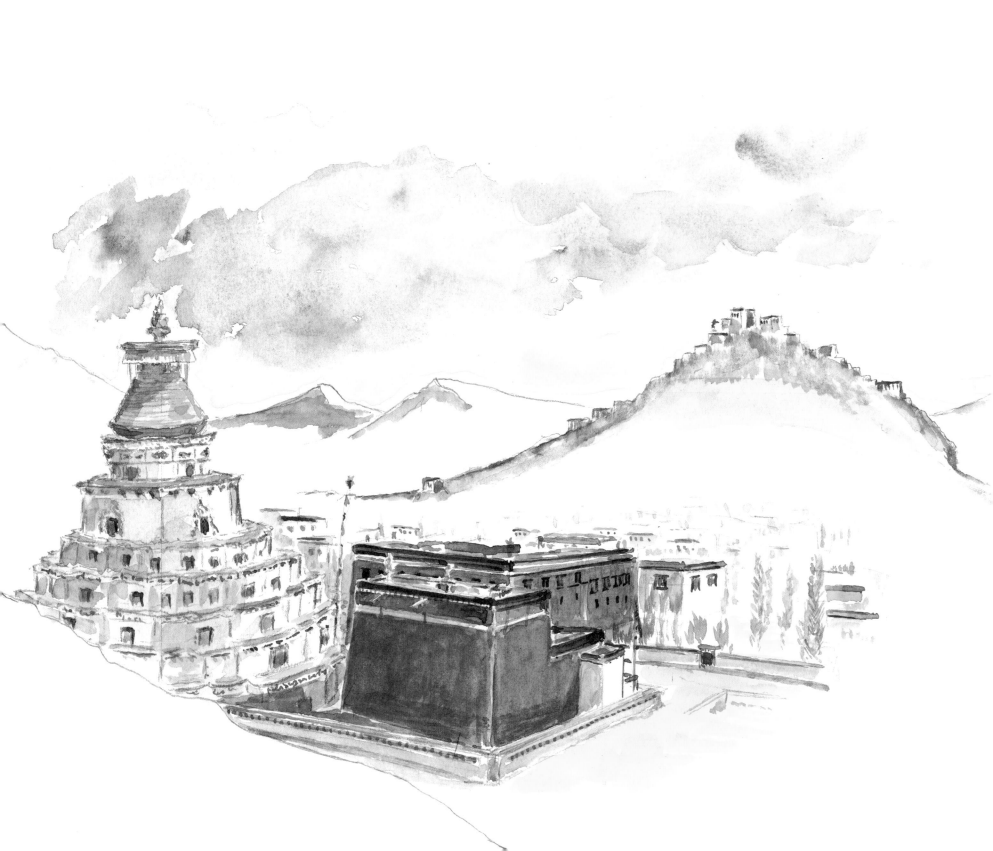

Gyantse, once the third-largest town in Tibet, had a small population of less than 8,000 under the Dalai Lamas.

in a trance, leaping from the rooftops between the buildings. The monasteries of Ladakh continue to accept the second sons of local villagers. The celibacy of the monks continues to help limit the birth rate, thus allowing the inhabitants of Ladakh and all of Tibet to live in relative abundance, by Indian and Chinese rural standards. In recent years this has excited the jealousy of the impoverished, land-hungry Muslim farmers of overpopulated Kashmir, who have tried to claim settlement rights in Zanskar.

In contrast to the arid western region, eastern Tibet is fertile, its granite mountains covered with forests, its pastures and fields lush and green. Farmhouses in the kingdom of Chala, not far from the traditional border of Tibet and Chinese Sichuan, often have a tall, free-standing tower, which serves not only as a watch-tower but also as a status symbol.

In many ways ancient Tibet was a relatively democratic society with a proud rich peasantry, not a downtrodden agricultural pro-letariat. The aristocracy was less powerful than elsewhere, which was appreciated by the farmers but became a liability when the country was attacked. In 1350 the Sakya lama, ruling for the Mongol Chinese emperors, was overthrown, and central Tibet was once again ruled by a king. For 300 years, independent of China, Tibet flourished under the combined rule of the related royal families of western, central, and eastern Tibet. From their forts in Shigatse and Gyantse, the royal families of central Tibet carried on the era of prosperity that had begun in the eleventh century. Gyantse was the third-largest town in Tibet for a long time. It owed its fame and importance to the size of its citadel and its location along the trade route to India (Bengal) and the mule trail that linked it to Lhasa and Shigatse, the greatest towns of Tibet. Gyantse is encircled by the walls of a fortress that dates

The elegant symmetry of Gongkar monastery's facade
conceals the splendor of the remarkable paintings inside.

back to the days of Songtsen Gampo; it was enlarged in 1365 and
again during the rule of the Fifth Dalai Lama.

The monastery of Palkhor Chode was founded in the fifteenth
century. At one time it held sixteen colleges of four different
schools, the Geluk, Sakya, Nyingma, and Shalu orders; today
only two colleges survive. In Gyantse nothing can outshine the
Kumbum Chorten, or "chorten of 100,000 images," the largest
chorten in Tibet. It was built in 1418 by Rapten Kunsang Phapa,
lord of Gyantse and a member of the Tibetan royal family. The
chorten contains seventy-three chapels linked by a spiral walkway
that ascends the monument. The chapels contain hundreds of
remarkable terra-cotta statues of Nepalese and Chinese influence.

The sixteenth-century Gongkar monastery in central Tibet
belonged to the Zung branch of the Sakya order and was founded
by Jamyang Khyentse Wangchuk (b. 1524). This sage was a great

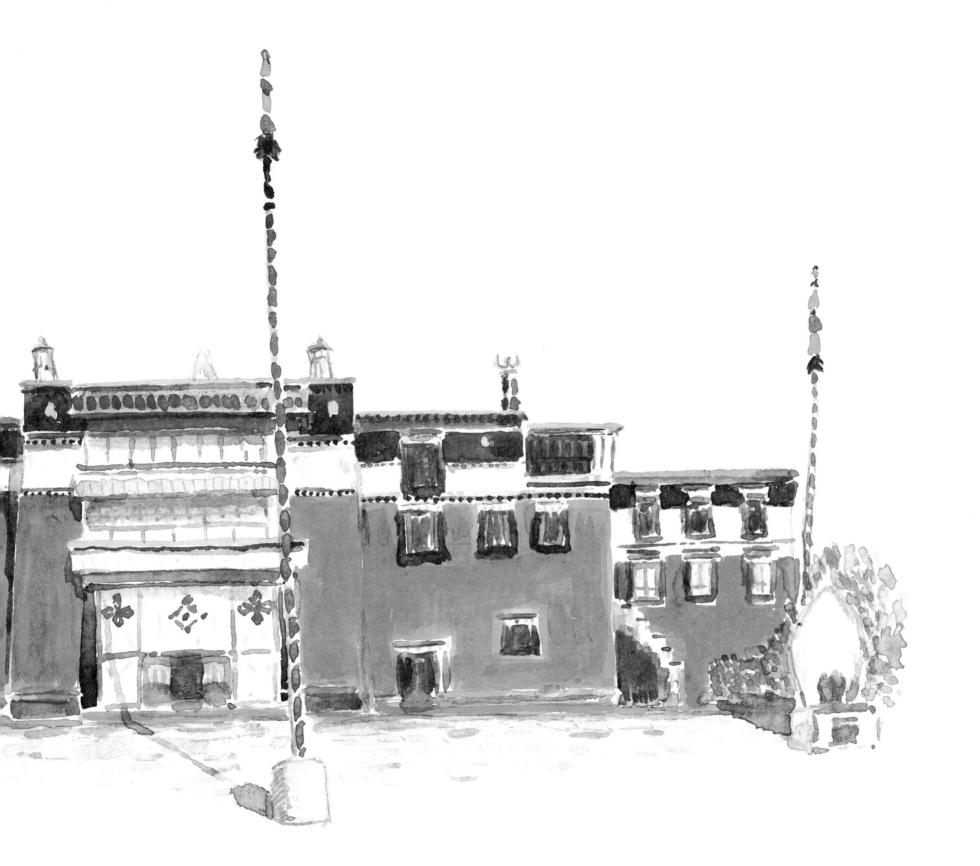

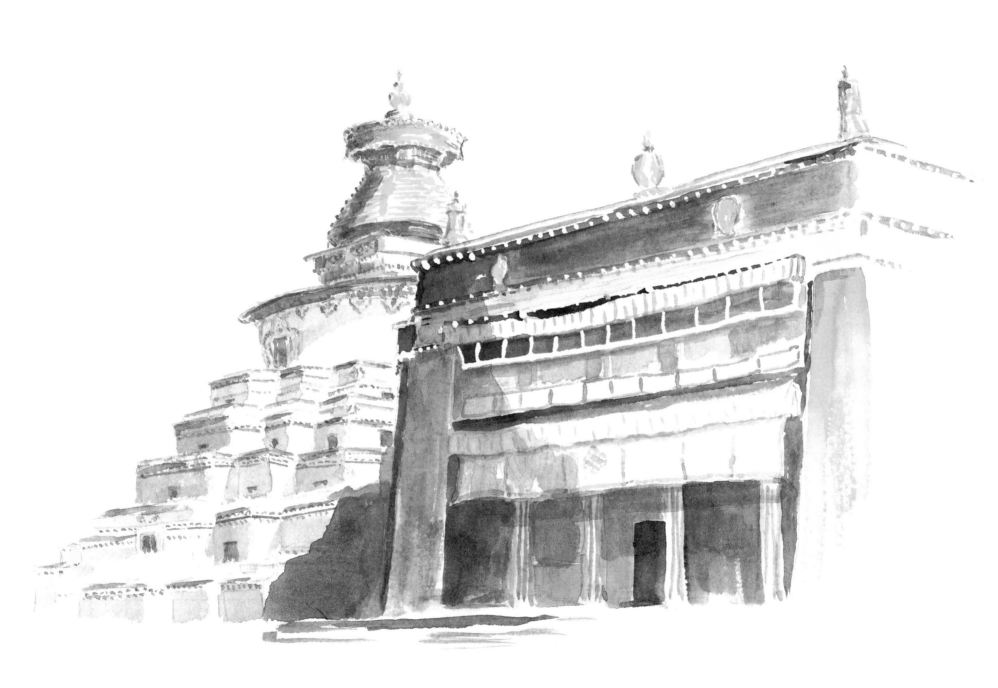

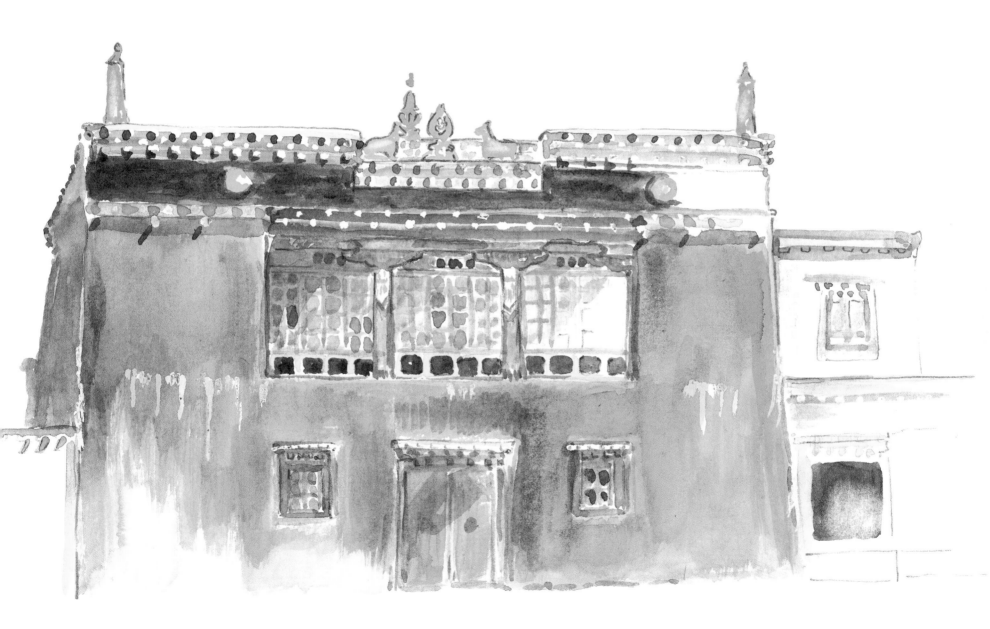

84 The Kumbum Chorten of Gyantse is one of the most remarkable monuments in Tibet. Consecrated in 1427, it contains 73 small chapels, with a total of 27,529 images (according to one recorded count).

85 The small monastery of Zaduo caters to the Ghegi nomads of the ancient Kham kingdom of Nangchen.

Unusual in shape, the monastery of Ekyongya stands in the heart of the territory of the fiercest of all the nomad tribes, the Goloks, who are pious bandits.

artist, and several of his murals are still visible today. These murals exemplify the golden age of Tibetan scholarship and art, and they are being preserved thanks to the efforts of the scholar Heather Stoddard. The monastery itself is a classic example of Tibetan religious architecture of the period.

Between 1300 and 1600 hundreds of new monasteries were built in the farthest provinces of Tibet, including the freezing, windswept plains that were home to the fierce nomad tribes. One such monastery is Zaduo, in the kingdom of Nangchen. I came upon this remote monastery while seeking the source of the Mekong River, in what is today the southern tip of the Chinese province of Qinghai. The small monastery stands above the Mekong, on the edge of the vast pasturelands of the Khampa nomads of Nangchen. It belongs to the Nyingma school, the oldest in Tibet, indicating that these remote regions were visited

in the eighth century by the first monks to enter Tibet in the wake of the mystic Padmasambhava. Emperor Trisong Detsen brought Padmasambhava to Tibet from Uddiyana (now Swat, in Pakistan), known in ancient times for its Buddhist magicians and mystics, to help convert the Tibetans and "slay" demons and dragons—the spirits of the local cults. There is hardly a grotto, river, mountain, or valley in Tibet that is not associated with some miraculous deed performed by Padmasambhava.

The nomads of Tibet are religious Buddhists, and they send their second sons to study with the monks. The monasteries of the plains are very rich because of the generosity of the nomads. Many of the nomads own huge herds of yaks and sheep, and they have little use for all the money they receive from the sale of wool and cashmere from their sheep and goats and the meat of their yaks. The one commodity they need is barley, for which they

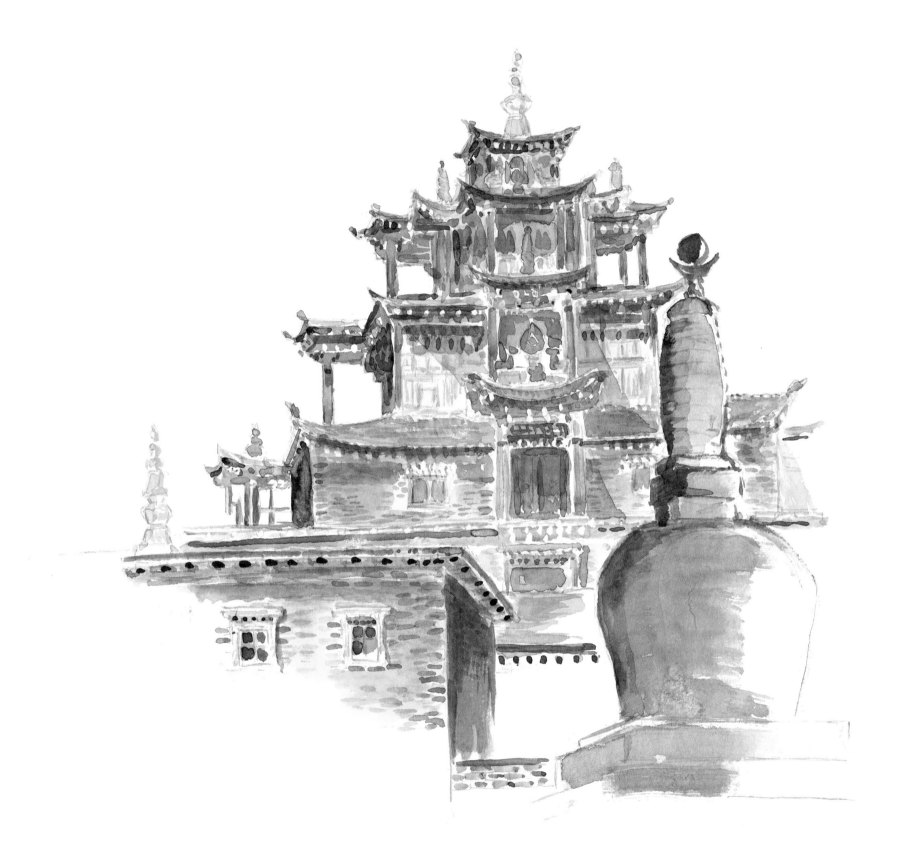

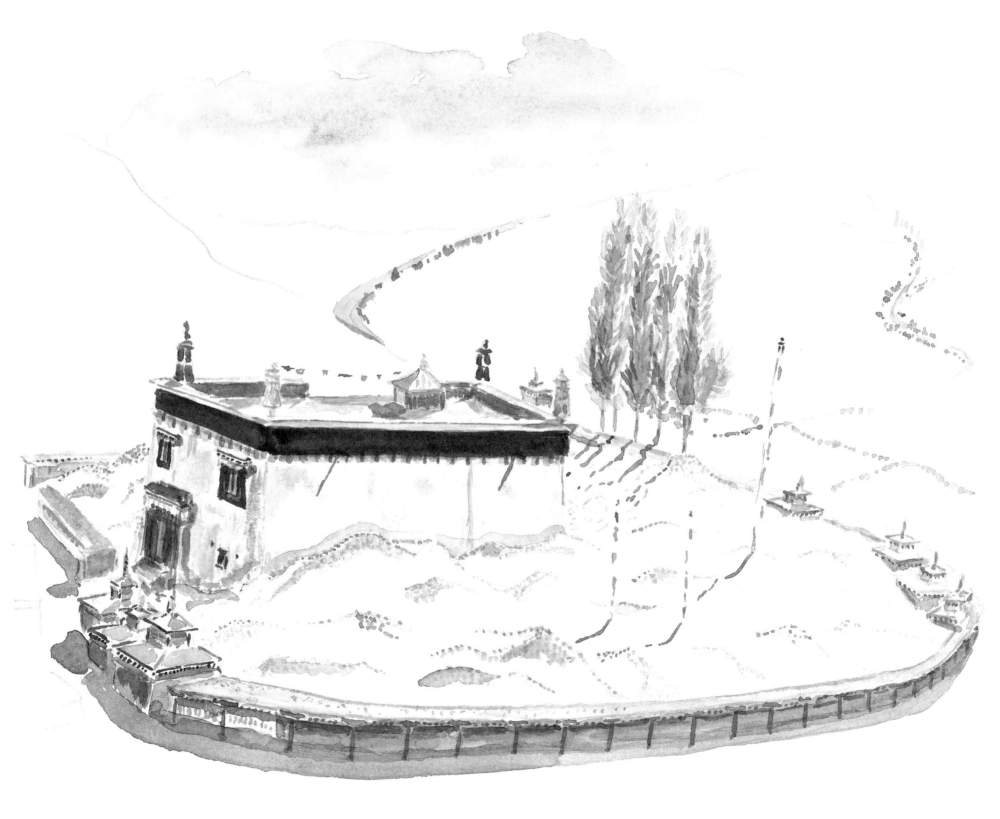

Piles of votive stones practically obstruct access to this small temple on the road to Riwoche.

90 Wangdu Phodrang straddles the strategic ancient mule trail across Bhutan that it once controlled.

trade salt. They do, however, enjoy spending money on jewelry, made of turquoise, amber, and coral, and gold-embroidered silk brocades.

The Golok nomads were famous for attacking caravans that dared venture into their territory. Whatever they could not buy they stole from those foolish enough to cross their land uninvited and unarmed. Yet their grasslands are dotted with monasteries such as the monastery of Ekyongya, south of the Amnye Machen range, which belongs to the Jonang school (an order founded in the early fourteenth century by a Sakya monk). Almost every family sent a son to study at the local monastery. Monks were not obliged to spend all their time at the monastery. They could travel throughout Tibet, India, Mongolia, and China on pilgrimages or trading missions, purchasing cotton for prayer flags, bark-pulp paper (abundant in Bhutan) to print books, or paints

and pigments to decorate their monasteries. The monks were also allowed to return home to their families whenever they pleased and help during the harvest or herding yaks in the summer, taking these opportunities to teach their older brothers how to read and write.

While seeking out new breeds of Tibetan horses in the remote northeastern highlands of Tibet, I came across a strange shrine: a chapel so revered by the local nomads that it had nearly disappeared under the votive stones brought there by pilgrims. This shrine is situated halfway between the remote valley of Riwoche and the Bon stronghold of Denchen. Every stone is carved with prayers, the most common of which is the mantra "*Om Mani Padme hum.*" The largest pile of votive stones I have ever seen was 150 feet high, marking the site of Nangchen Gar, the campsite capital of the federation of twenty-five nomad tribes that formed

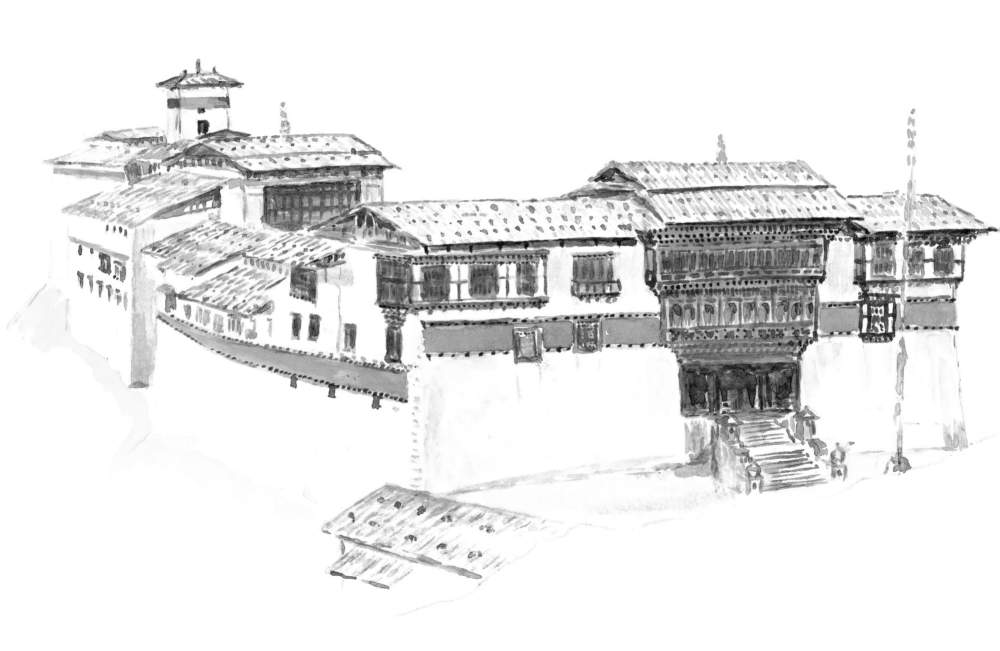

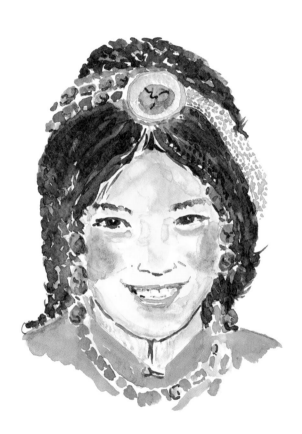
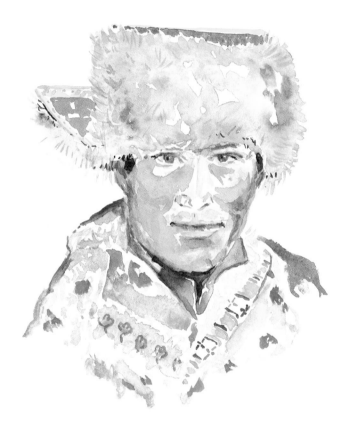

A handsome couple from the kingdom of Chala in Kham.

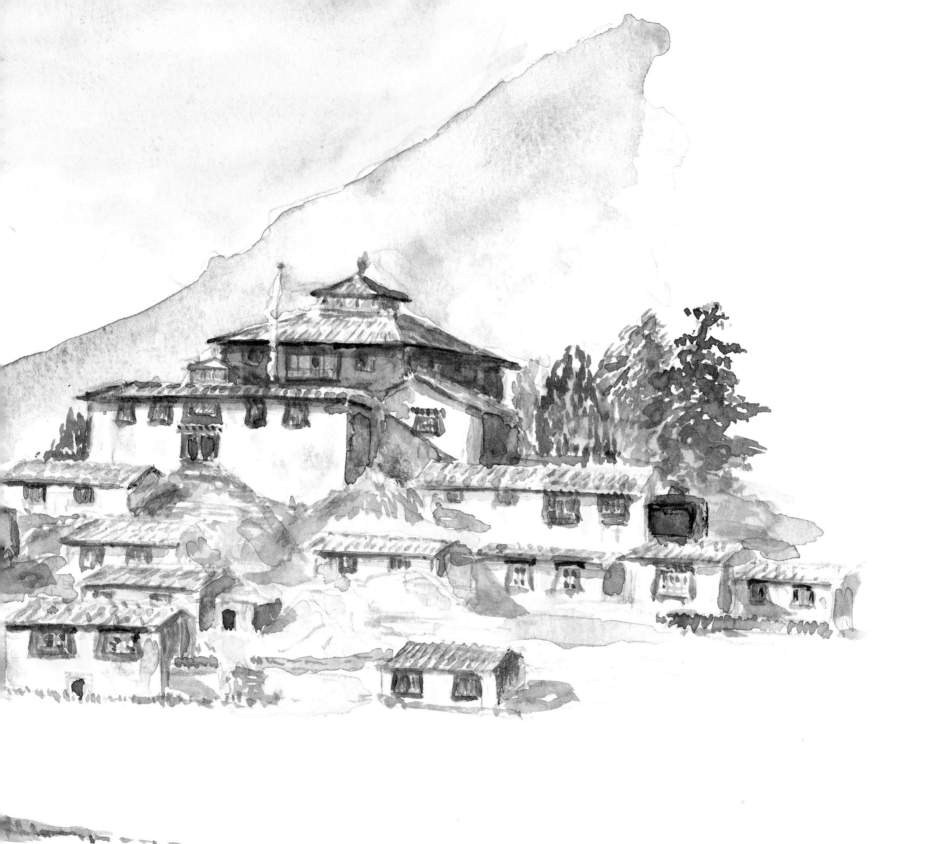

92–93 Tyangboche monastery stands in the heart of the Khumbu district of Nepal, home of the Sherpa. The monastery was a stopping place for early expeditions to Mt. Everest.

the independent kingdom of Nangchen. Despite its large size and long duration, Nangchen was little known, visited by only a handful of foreigners since its eighth-century founding. In 1948 the king offered Mao Tse Tung 1,000 mounted horsemen to help him fight the infamous Muslim warlord Ma Pu-fang, who ruled part of Amdo. The Communists repaid this good-will gesture by seizing the king and taking over his vast domains in 1950.

Close to a thousand miles southwest of Nangchen rises the charming little monastery of Tyangboche, a few miles from Mt. Everest, in the heart of Sherpa country. Many a mountaineer found shelter here in the early days of the conquest of Everest by the southern route. The monks here live in tiny, hut-like cells that surround the assembly hall. The Sherpa people, whose name means "easterner," are believed to come from Kham, in eastern Tibet. Living on the southern face of the Himalayas, exposed to

the monsoon rains, Sherpas live in homes that have slanted roofs of split-pine planks weighted down by stones. This style is also seen in Bhutan and several regions of central and eastern Tibet, as well as in Switzerland.

On the eastern side of the Himalayas lies Bhutan. The true name of this kingdom is Drukyul, the land of the Druk subsect of the Kagyu school, named after a monastery in central Tibet. Bhutan was an integral part of Tibet until the Fifth Dalai Lama's rise to power in 1655. Called the Great Fifth, but known by others as the father of the ruin of Tibet, Losang Gyatso (1617–1682) was a crafty, brilliant, and ambitious politician. As he sought to control what had been the immense domain of the first kings of Tibet, he began a long series of campaigns against the royal families that ruled Tibet and the monks of the most prominent rival orders. Among these were the powerful Druk monks of Ladakh and Bhutan.

A guard house at the foot of Lhuntse Dzong, in eastern Bhutan.

The monasteries of Bhutan are called *dzongs* ("forts") because they were built to shelter monks and ward off attacks not just from the Dalai Lamas' troops—who attacked Bhutan three times—but also invaders from India and adjacent fortresses. Set on an island, the fortified monastery of Punakha is one of the most dominant in the region. It is a superb example of the elegance of Tibetan architecture, mixing the functional with the aesthetic. For more than 100 years this huge, shiplike fortress appeared on world atlases as the capital of Bhutan, yet it was inaccessible by road and closed to all foreigners. It was the winter residence of the Shabdrung, the incarnate lama of the Druk order (called Dharma Raja, or "religious king," by the British). The Druk monks preferred British patronage to that of the Qing emperors of China, Manchu Mongols who supported the Dalai Lamas, and thus remained neutral when the British invaded Tibet

in 1904. The British soon tired of dealing with the monks, and they encouraged the establishment of a secular monarchy. In 1907 Urgyen Wangchuk, the head of the Tongsa fortress in central Bhutan, became the first king. Three years later the country became a British protectorate, later handed over to India, but in 1949 Bhutan regained its independence. Bhutan is now the only independent state left of the great Tibetan empire of Songtsen Gampo.

Paro Dzong is the most elegant of Bhutan's thirty-two great forts. Accessible in the rear by a drawbridge and overlooked by a second fort of semicircular towers, Paro has perfect proportions and simple lines. Its massive structure merges perfectly into the rocky foundations. The line of windows that open onto balconies and latticed galleries, broadening as they rise toward the elegant garnet frieze, gives the building a festive air that contrasts with

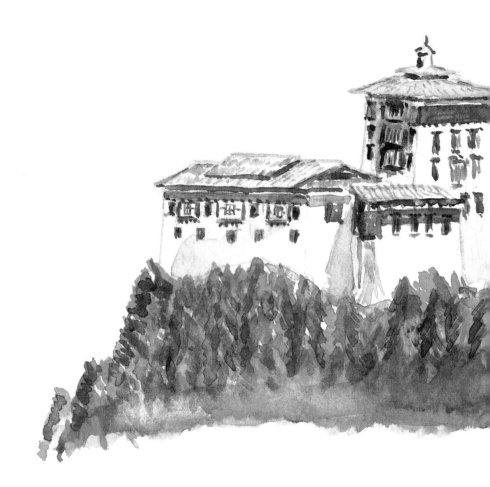

Overlooking the wooded rich valley of Bumthang, the Valley of the Hundred Thousand Plains, Jakar Dzong proclaimed the authority of the monks and their lay administrators.

the heavy masonry. Several different fortresses occupied this site, but the present *dzong* was first built in the 1640s by Shabdrung Ngawang Namgyel, the founder of Bhutan. Destroyed by fire 100 years ago, it was rebuilt and contains remarkable recent frescoes.

The fortress of Wangdu Phodrang, seven miles south of Punakha in the Mochu Valley, is another fine example of a fortified monastery. Located upon a strategic crest at the meeting of two rivers, it controls the trade routes to Tibet and eastern Bhutan. Its high walls surround the Uchi, or central keep. Cactus grows at the foot of the walls, adding further protection. The Himalayan valley enjoys an exceptionally hot microclimate, and timber is abundant; thus, the monastery has many windows, and the upper walls resemble Tudor-style architecture. A steep, ladder-like staircase, which can be withdrawn in case of war, leads to a single, massive doorway.

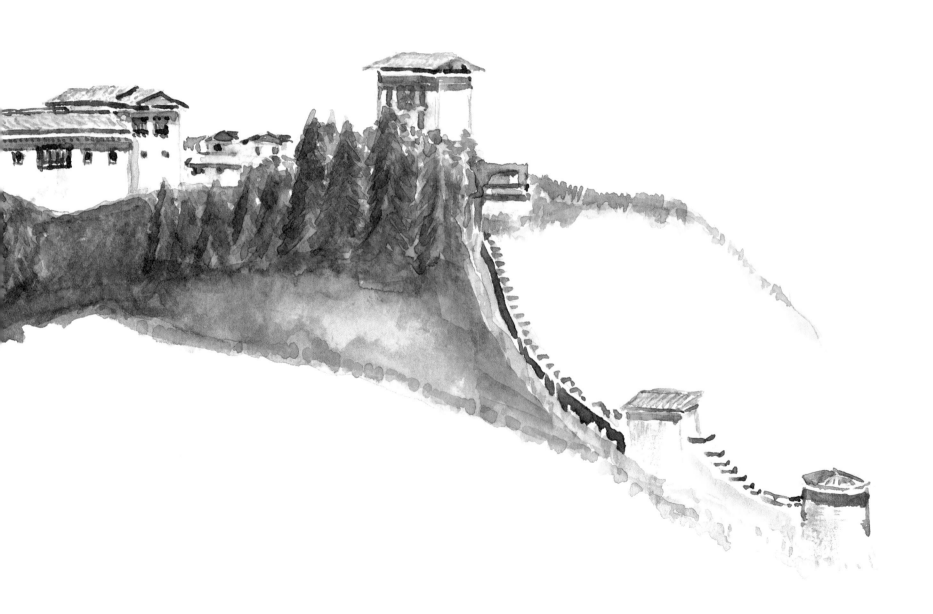

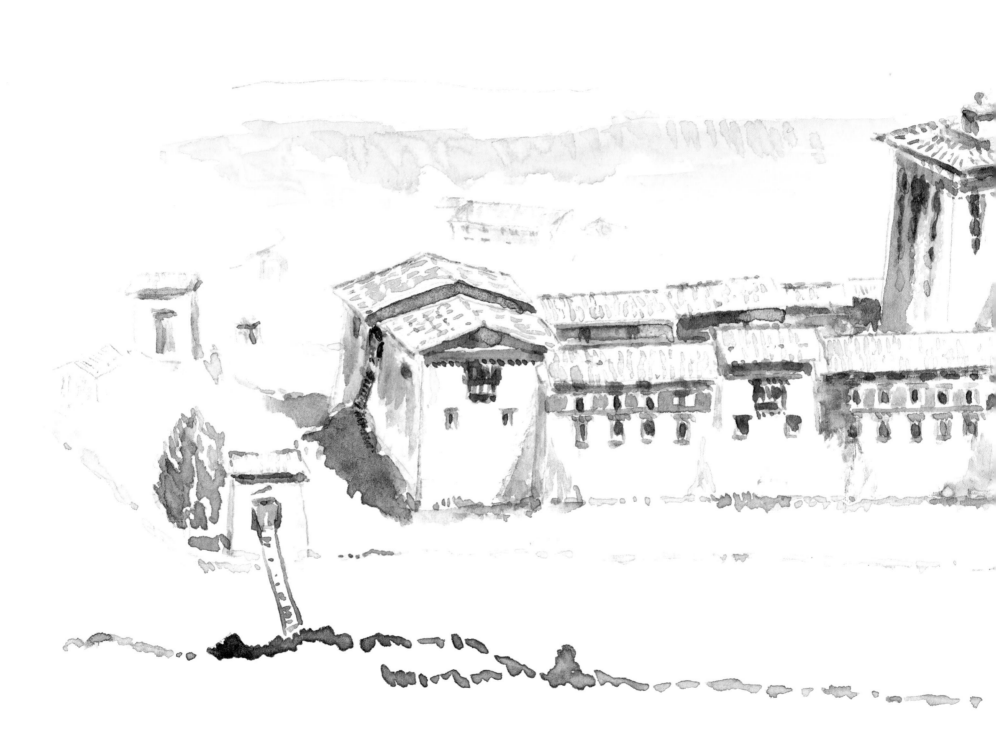

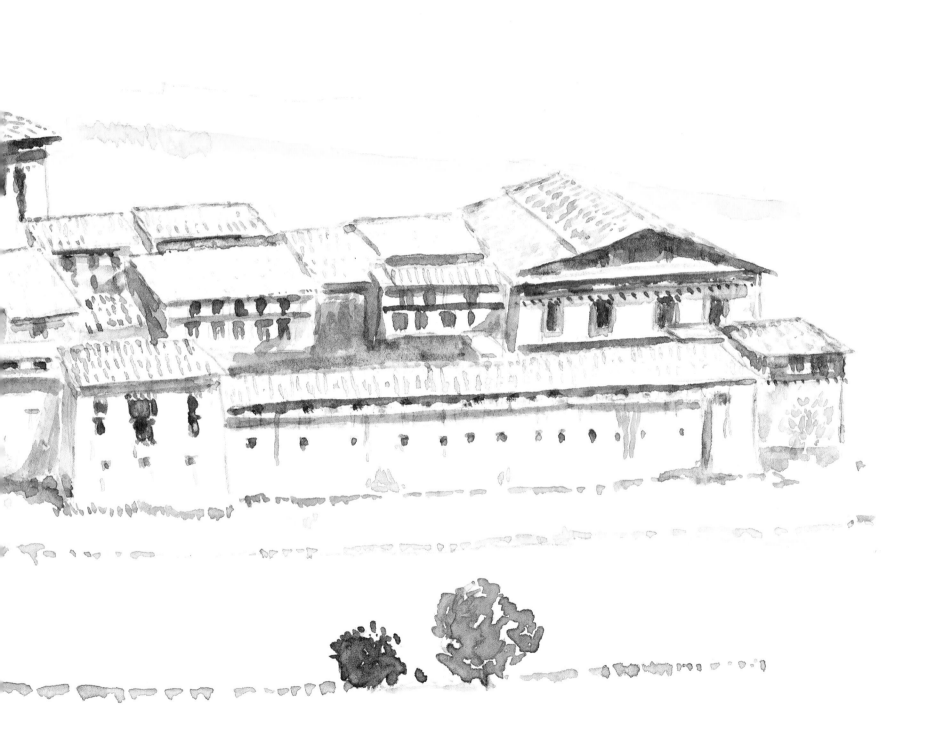

Paro Dzong is a fine example of the impressive
elegance of Tibetan architecture.

98–99 Punakha was the winter capital of Bhutan.

At this door in 1968 I formally handed over to the Ramjam, the
second in command, the government scroll allowing me to requi-
sition horses and porters in all the fortresses of the land, in order
to cross what was then forbidden Bhutan—foreigners were only
allowed to visit by special invitation from the king. Halfway across
Bhutan I reached the enchanted Valley of the Hundred Thousand
Plains, Bumthang. Its seventeenth-century fortress, Jakar Dzong, is
yet another example of the emergence of monasteries as political
and military centers. By then Tibet had become a land of fighting
monks, as the Dalai Lamas vainly attempted to conquer all of Tibet.

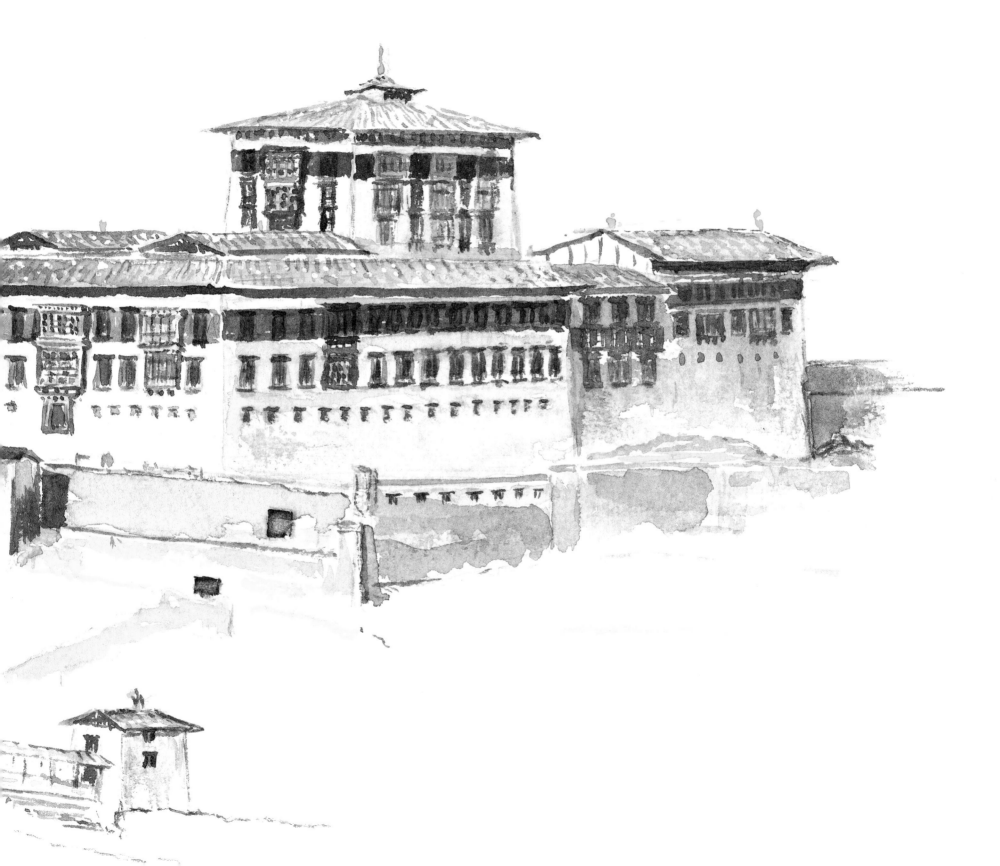

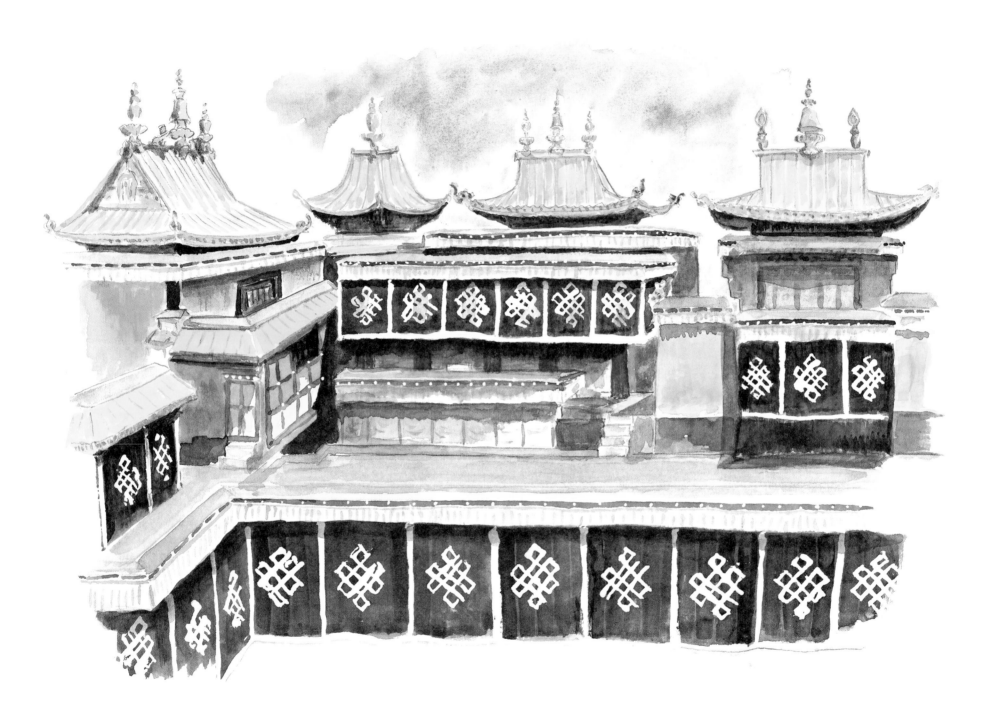

The Reign of the Dalai Lamas

Crested in gold and draped in the yak-hair tent cloth
of Tibetan nomads, the Dalai Lama's apartments dominate
the Potala palace.

The Potala was built as a stronghold by the Fifth Dalai Lama over the nine-story palace of Songtsen Gampo. The white palace, the eleven-story central portion, was begun in 1655 and completed in three years. The red block containing chapels and residential suites was built between 1679 and 1705 by the regent Sangye Gyatso.

106–107 A rare frontal view shows the full dimensions of the Potala, one of the most impressive structures in Asia.

The Potala is the most famous of all Tibetan buildings. This gigantic fortress, begun in 1655 on the remains of Songtsen Gampo's palace, symbolizes the power of the Fifth Dalai Lama, the first to rule Tibet. It is a fortress, a prison, a palace, and the resting place of the deceased Dalai Lamas. Over the centuries it was enlarged, and today the Potala is one of the most impressive buildings in Asia. Here the monks amassed tremendous wealth: Gold plated the roofs of the Dalai Lama's apartments and the tombs of the past Dalai Lamas, and an immense treasure was stored in the lower chambers next to the prisons. This treasure was shipped to India for safekeeping in 1950, nine years before the Dalai Lama himself left Tibet.

The Potala is a monument to what quickly became a rigid monastic bureaucracy, one keen to impose its conservative law through force and intimidation, with help from its mighty Mongol and later Manchu patrons. The Dalai Lama's administration from the secure bastion of the Potala led Tibet into civil war and the disintegration of its vast homeland. This history, an example of how religion and politics are a combustible mix, is rarely told. It is difficult to reconcile the saintly image of the current Dalai Lama with that of the past government that was feared by many and whose authority was never accepted by the majority of Tibetans. Those in central Tibet who dared to oppose the regime died in the ground-floor prisons of the Potala.

The story of the Dalai Lamas begins with Sonam Gyatso (1543–1588), the lama of Drepung monastery, which belonged to the Geluk order founded in the early fifteenth century by Tsong Khapa (1357–1419). The Geluk school, also called New Kadam because Tsong Khapa was dedicated to the teachings of Atisa, greatly expanded the rule of reincarnated lamas and reintroduced

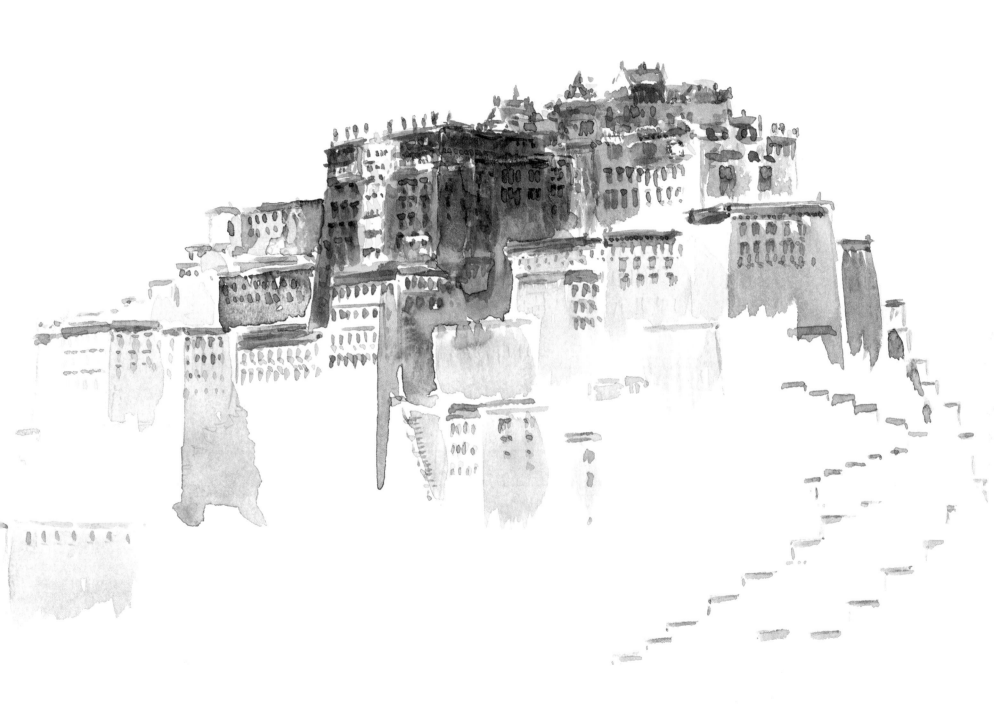

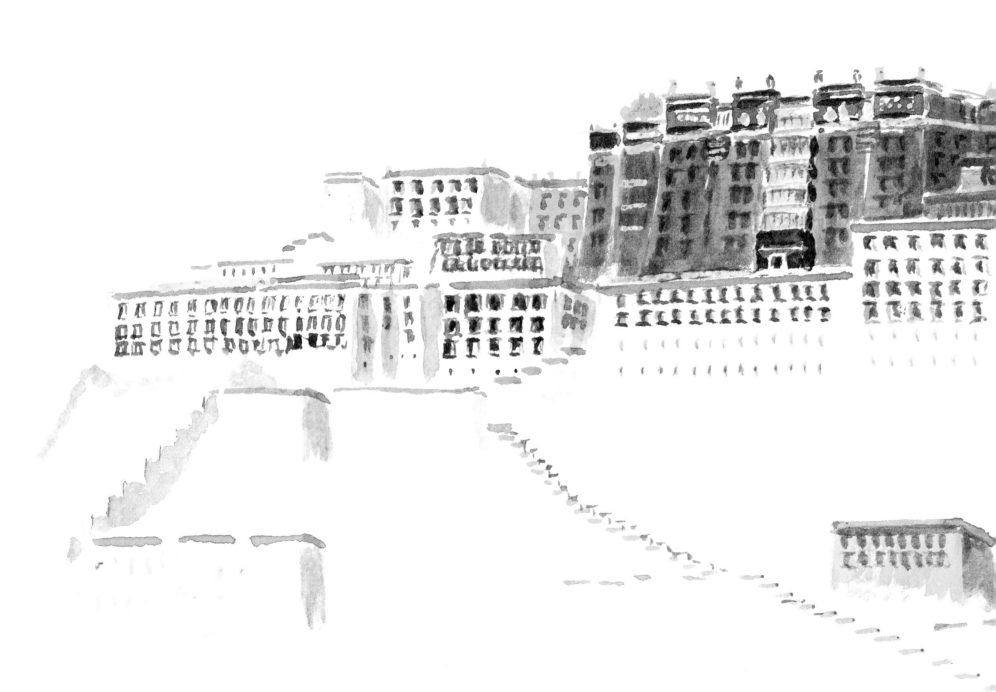

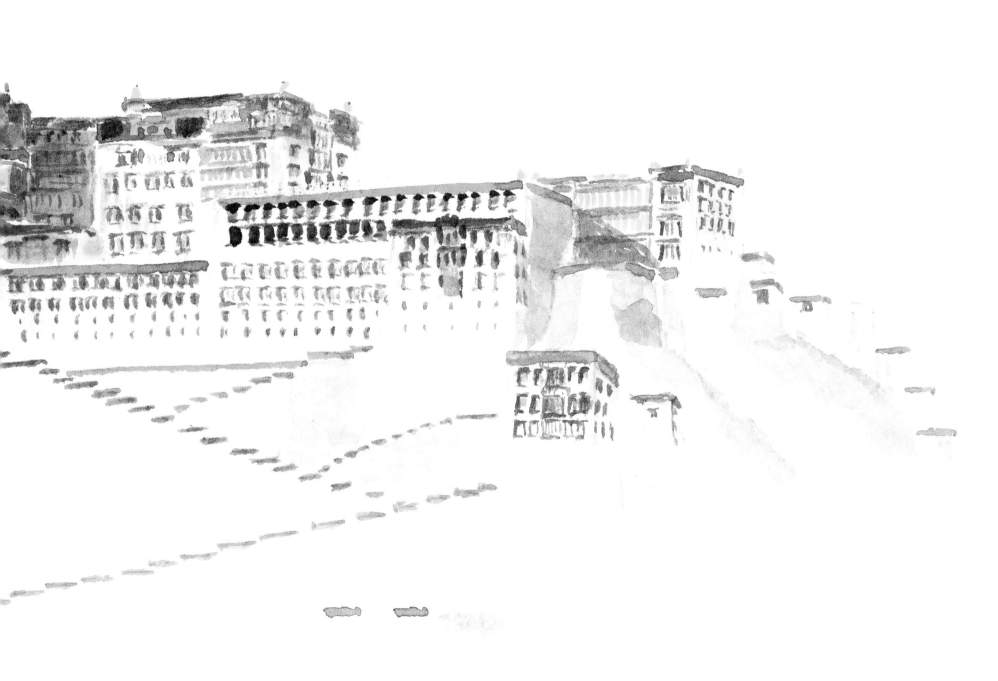

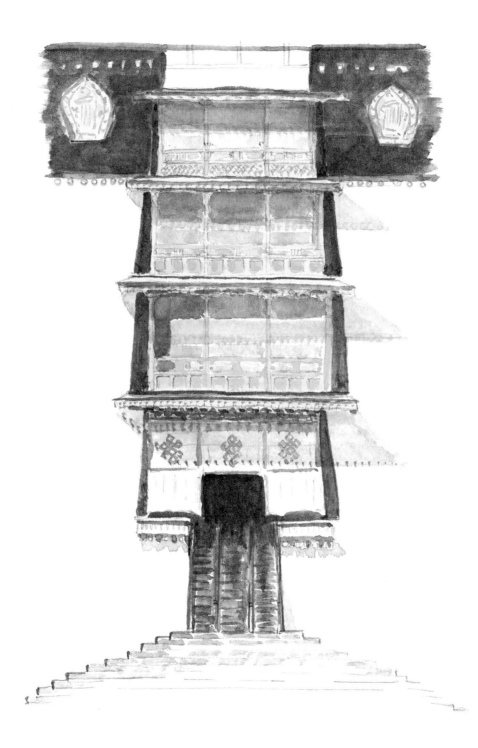

Three steep, ladderlike stairs lead to the Dalai Lama's apartments. The central flight was for the exclusive use of the Dalai Lama.

110–111 The great assembly hall of Sera monastery is a masterpiece.

strict discipline, spirituality, and austerity into monastic life. An extremely influential missionary, Sonam Gyatso succeeded in converting nearly all of the many Mongol tribes. Altan Khan, the head of the powerful Tumed clan, gave him the title of *Ta le* (Dalai), the Mongolian translation of Gyatso, which means "ocean." The title was then retroactively applied to the two lamas before him, making Sonam Gyatso the Third Dalai Lama. As if by miracle, the fourth reincarnation of the Dalai Lama was found to be a young Mongol—the grandson of Altan Khan.

The Mongols at the dawn of the seventeenth century were divided into nearly a dozen clans, who shared the spoils of the once great Mongol Empire of Genghis and Kublai Khan and later Tamerlane. The conversion of the Mongols to the Geluk order gave the Dalai Lama considerable prestige and power over the various rival Mongol princes. The primary Mongol groups were the Dzungar federation in the west, the Manchu (who started the Qing dynasty in China in 1644) in the east, and the Dalai Lama's main supporters, the Tumed and Qosot Mongols, in the central region. In 1642 Gushi Khan, the leader of the Qosot Mongols, traditional enemies of the Tibetans, invaded central Tibet with the approval and help of the Fifth Dalai Lama. The Mongols killed the legitimate Tibetan king of the region, who had backed the rival Kagyu monks. Gushi Khan then named the Fifth Dalai Lama as his spiritual and later political representative in central Tibet. When Gushi Khan died in 1655, the Fifth Dalai Lama, a Tibetan, assumed full political power over central Tibet.

The Geluk monasteries were enlarged, and the Sera, Ganden, and Drepung monasteries in Lhasa became both political and military strongholds—each with its own army—and their great abbots became the backbone of the Dalai Lamas' administration.

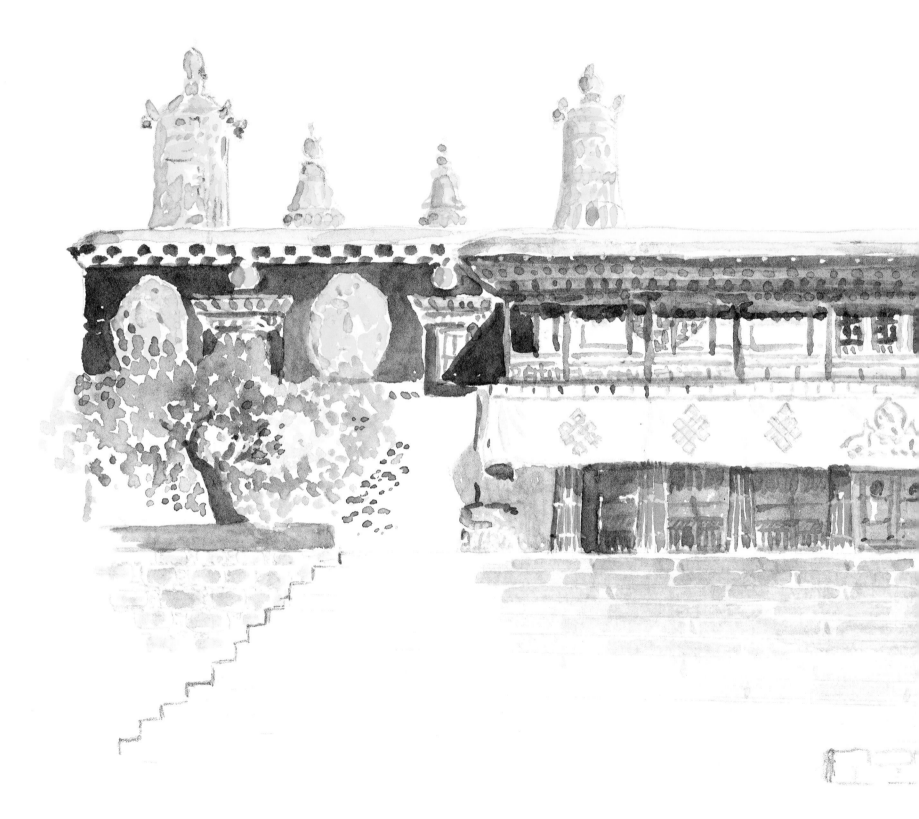

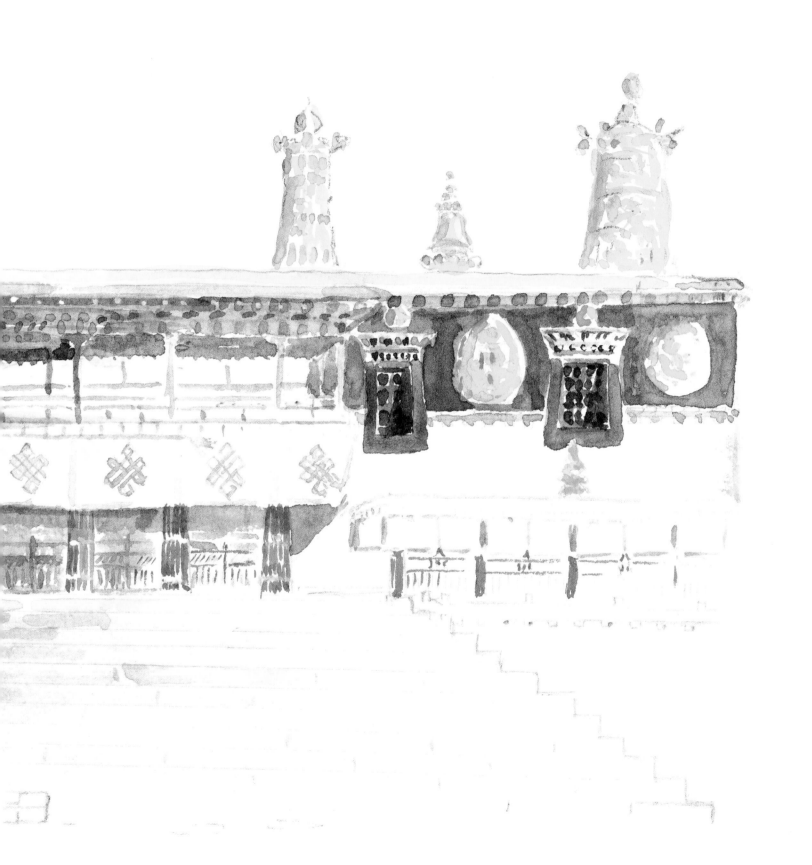

A gaudy, highly decorated capital of Indian Buddhist inspiration.

113 One of the several magnificent temples of Tashi Lhunpo monastery, displaying the wealth of the Panchen Lamas.

The monks ruled Tibet, in effect, while the successive Dalai Lamas were minors—and more often than not the young Dalai Lamas were murdered when they came of age. Thus, the Dalai Lamas became mere holy figureheads of a tyrannical monastic bureaucracy. In the nearly 300 years between 1655 and the Chinese takeover in 1950, only two Dalai Lamas actually ruled Tibet: the Great Fifth and the Great Thirteenth, who died in 1933. The two could hardly have been more different. The Thirteenth Dalai Lama spent his life trying to reunite greater Tibet and regain independence, attempting to mend what the Fifth Dalai Lama had undone.

The Dalai Lamas gave Tibet its richest and most flamboyant monasteries. The grand assembly hall of Sera monastery is a marvel of harmony, but it serves foremost as an elegant front for hanging banners. Pilgrims rarely see the same building, as one year it may be draped in saffron and red, and the next, blue and white or dark brown and white. It is considered a great deed to donate a new set of drapes to decorate a monastery or temple, and rich herders keep the tentmakers busy.

The vast Labrang monastery stands in what is today the Chinese province of Gansu. When it was founded in 1709, this extreme northeast region of Tibet was a Geluk stronghold. The monastery was paid for by the Mongols and housed 4,500 monks. Labrang also controlled about 100 subsidiary monasteries, half of which were located in Mongolia and Amdo, one in Beijing, and others in distant Sichuan. Built in 1791, Labrang's Golden Temple houses a giant statue of Maitreya, the future Buddha. The monastery was famous for its medical school and its colossal library, which contained more than 20,000 volumes. These buildings were all part of a large complex of buildings, but the Red Guards destroyed forty-

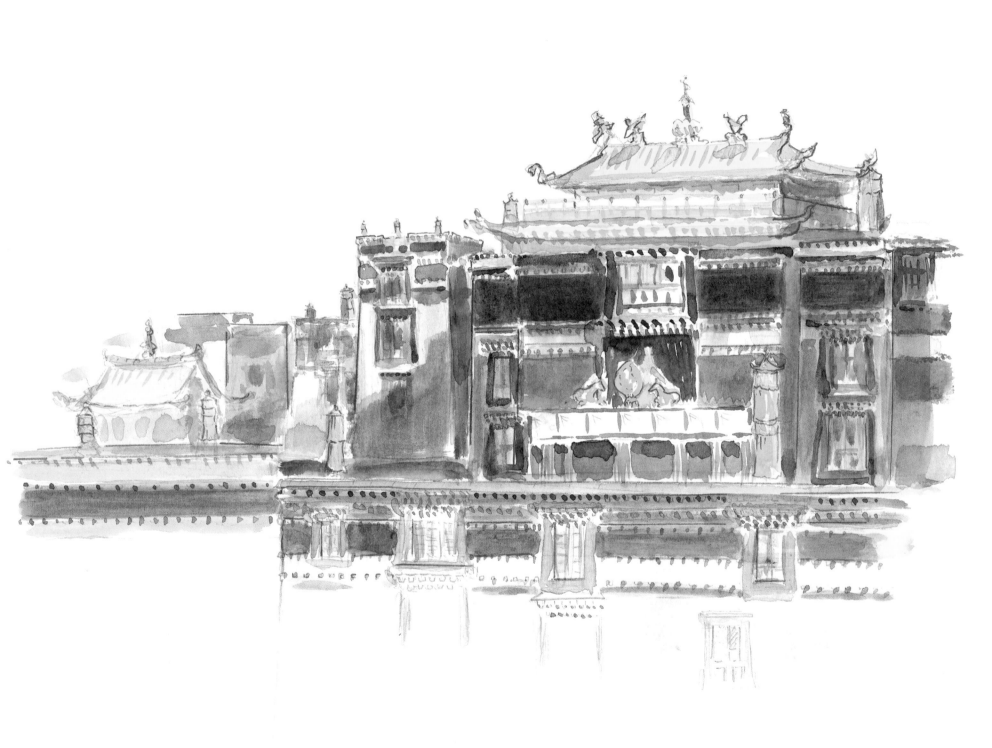

Founded in 1057, Reting was the first Kadam monastery. It was later home to the crooked regent of the Fourteenth Dalai Lama.

eight of Labrang's chapels and assembly halls and most of the monks' quarters. Today the entire monastery has been rebuilt and comprises more than a thousand buildings; it is a fine example of old and new Tibetan architecture. Labrang is proof that Tibet originally extended across the whole of the highlands of central Asia, despite China's claims otherwise. This vast territory was united until the Dalai Lama's administration divided the land and allowed the Chinese, the Mongols, and the Indians under British rule to annex any region that refused the despotic rule of the Dalai Lama.

The Fifth Dalai Lama had the support of all the Mongol tribes, and thus his principal enemies were the Tibetans themselves: the ousted royal families of central Tibet, the kings of the eastern and western regions, the ruling families of the south (Sikkim and Bhutan), and the abbots and monks of the powerful Red Hat sects,

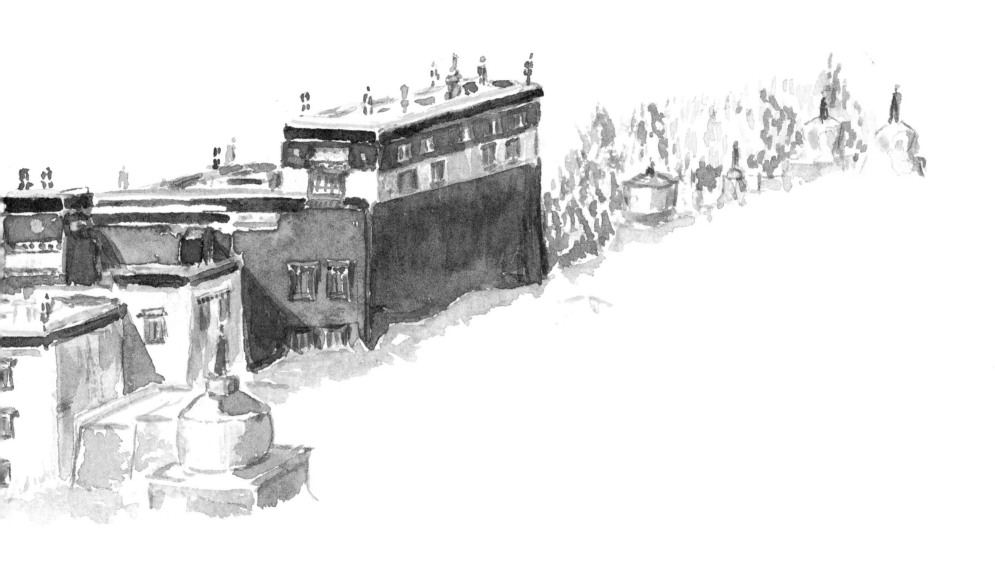

This open-latticed summer palace set in the Norbulinka
gardens was rebuilt by the Thirteenth Dalai Lama.

the Karmapa and Drukpa. To fight this opposition the Fifth Dalai Lama dispatched an army of Mongol soldiers under the leadership of the monk Ganden Tsewan, a member of the Dzungar Mongol royal clan. The infamous Ganden Tsewan fought the great fortified monasteries of the Drukpa, in what became Bhutan, while also attacking the kings of Sikkim and Ladakh. As discussed earlier, these campaigns were followed by long wars against the royal family of western Tibet, which was pushed back into Ladakh. At the same time, the Dalai Lama's troops fought the rulers of eastern Tibet, who were obliged to seek help from their Chinese neighbors.

In short, the Fifth Dalai Lama fought Tibetans right, left, and center in a bid to control all of what had been the vast Tibet of Songtsen Gampo. But the Great Fifth and his successors failed. They succeeded only in capturing Guge and the nomad lands

of Ngari in the west, and the province of Chamdo in the east. Thus divided, Tibet was fragmented and weakened forever. On the death of the Fifth Dalai Lama in 1682, he was succeeded by the regent, Sangye Gyatso, who was rumored to actually be the Dalai Lama's son. Gyatso ruled as regent for twenty-five years in place of the Sixth Dalai Lama, who was a libertine and a lyrical poet, not interested in administrative matters. Sangye Gyatso was very friendly with Ganden Tsewan, who was now the leader of the huge Dzungar Mongol coalition.

The Manchu emperor of China saw this alliance as a threat and encouraged Lhabzang Khan, the grandson of the Qosot Mongol Gushi Khan, to overthrow and kill Sangye Gyatso and depose the Sixth Dalai Lama, who died a short while later. Lhabzang then hastily named a new Dalai Lama, but the Tibetans refused his candidate. They chose their own new Dalai Lama, a child from

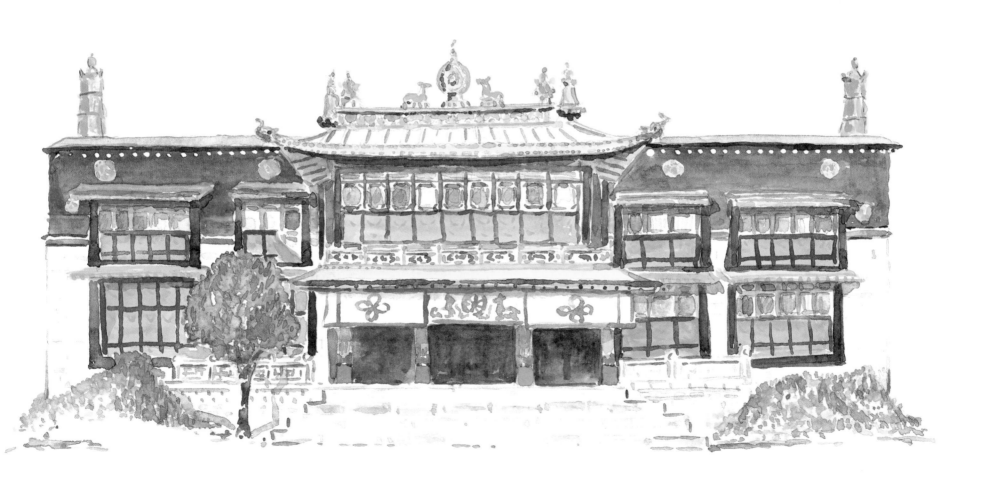

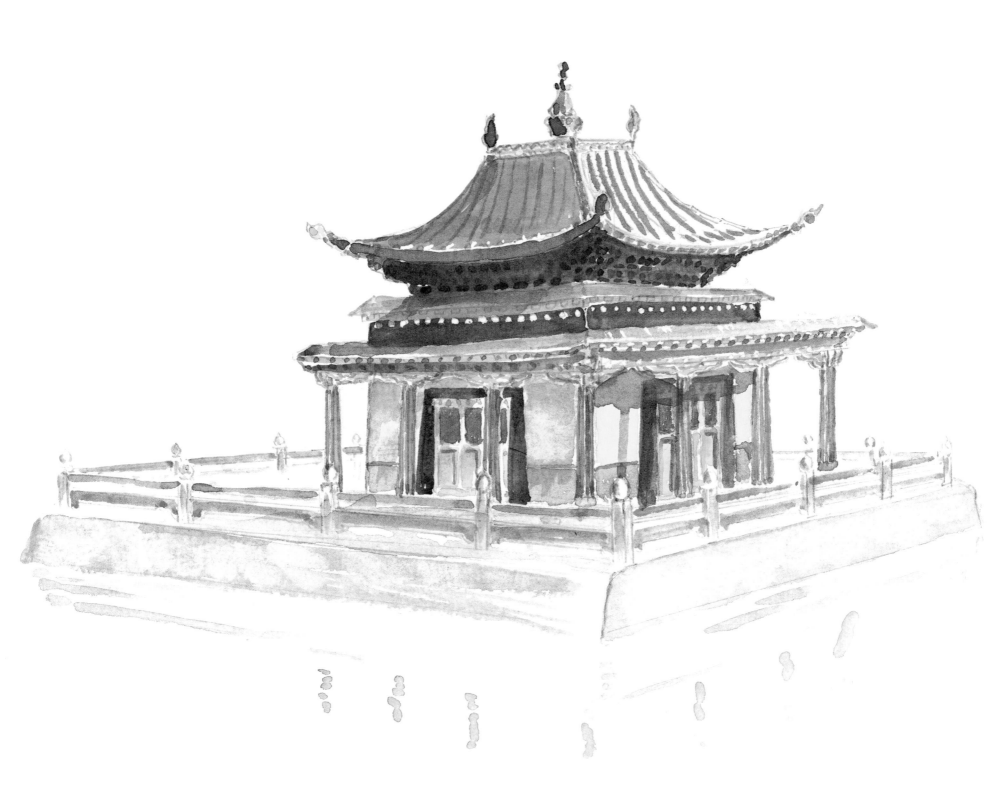

This pavilion on an island in the park of the summer palace near Lhasa is definitely Chinese in style.

far-away Litang in eastern Tibet, following a prophesy of the Sixth Dalai Lama. Ganden Tsewan took advantage of the turmoil in Lhasa to invade Tibet and kill Lhabzang, and he chased out the Qosot Mongols and their unpopular Dalai Lama.

The people at first welcomed the Dzungars—but the Dzungars betrayed their trust, sacking the monasteries and raping the local women. The Tibetans thus turned for help to the Manchu emperor. The emperor sent an army into Tibet, but it was defeated by the Dzungars in 1718. Two years later the Manchu force defeated the Dzungars and finally reached Lhasa, bringing with them the young Dalai Lama from Litang. This marked the first official submission of Tibet to China. The Manchu emperor was recognized as protector of central Tibet, and he took control of most of northern Amdo and Kham, in eastern Tibet.

By this time the Dalai Lama's realm was one-third the size and less than half the population of the old Tibet. It was a protectorate of the Buddhist Manchu emperors of China; it remained thus until 1911. During the three centuries of the Dalai Lamas' rule the rest of Tibet fell under the control of British India, Nepal, and China. Protected by the Chinese, the Dalai Lama's administration concentrated on enriching its monasteries at the expense of the Tibetan aristocracy and farmers. The estates of aristocrats were confiscated and handed over to favorites or family members of the Dalai Lamas or the regents. The monasteries became huge landowners, and the once independent farmers became impoverished serfs who worked the monks' land. In the Tibetan regions not controlled by the Dalai Lama—Ladakh, Zanskar, Mustang, Bhutan, and Kham—the farmers still owned their fields much as before.

The Seventh Dalai Lama built himself a summer palace in Lhasa, later embellished by the Thirteenth Dalai Lama. This luxu-

Tashi Lhunpo, the huge monastery of the Panchen Lamas, stands as a reminder of the excessive wealth accumulated by monks of the Geluk order under the rule of the Dalai Lamas.

rious retreat, set in a vast park with recreational pavilions, still stands as a fine example of secular Tibetan architecture. The green pavilion, heavily influence by Chinese architecture, is set upon an islet in a pond.

To better control Tibet and the Dalai Lamas, the Manchu emperors built up the wealth of the Panchen Lamas, establishing them as potential rivals. The Panchen Lamas came to control much of the richest land in Tibet, in and around the town of Shigatse. The line of Panchen Lamas had been created originally by the Fifth Dalai Lama. They were the abbots of Tashi Lhunpo, a monastery founded in 1447 by the First Dalai Lama, a nephew and disciple of Tsong Khapa. Tashi Lhunpo grew in wealth and importance as its estates were extended by successive Panchen Lamas, and today it is a formidable monastic city.

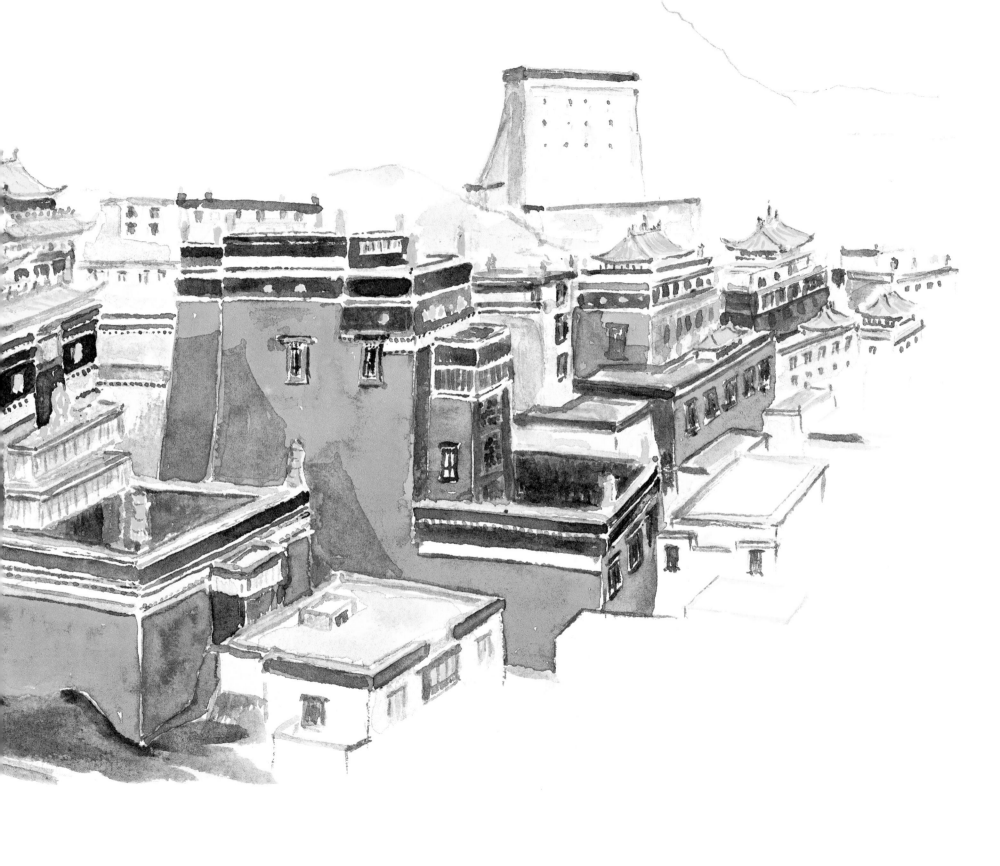

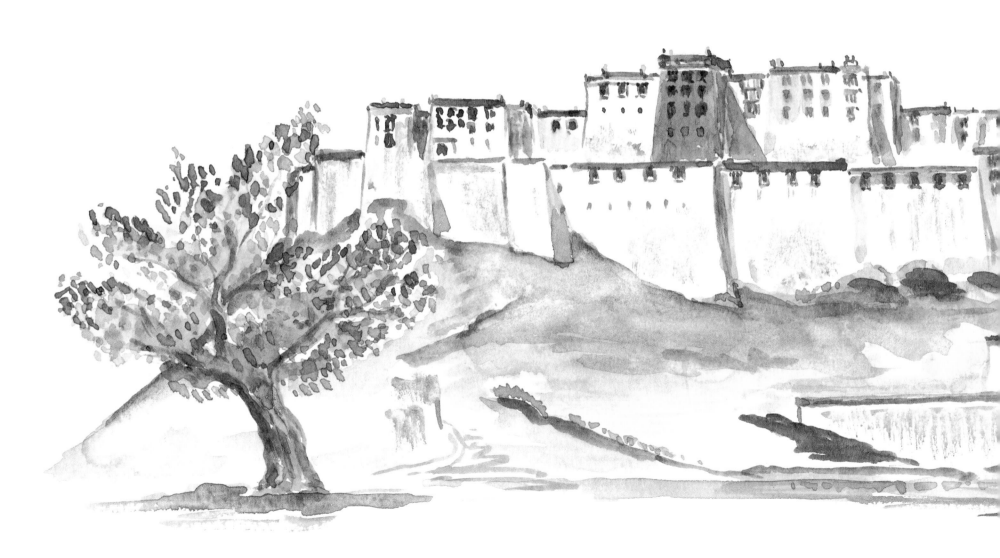

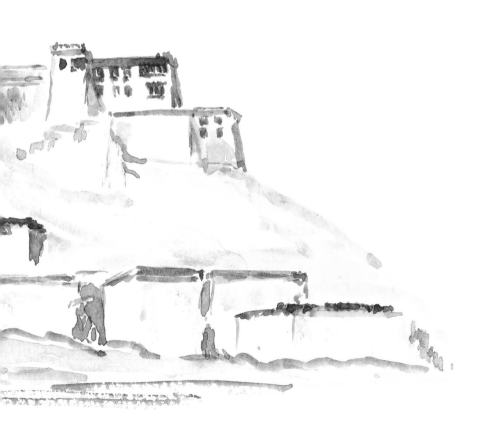

The great fort of Shigatse, here copied from an old photograph, was destroyed by the Chinese. Only a barren rock remains to stand over Tibet's second-largest town.

A row of temples houses the mausoleums of past Panchen Lamas. In 1791 the Nepalese invaded Tibet and sacked the monastery, stealing the treasure of gold and jewels. Outraged, the Manchu emperor sent an army across Tibet to defeat the Nepalese, pursuing them to Kathmandu. The treasure was regained, and Nepal was obliged to pay China an annual tribute. Next to Tashi Lhunpo stood the great fort of Shigatse, which dominated what was the second-largest town in Tibet after Lhasa; today the great fortress is in ruins.

More than a century later, after the Communists gained control in China, they too tried to set the Panchen Lama against the Dalai Lama. He, the tenth and last Panchen Lama, refused to attack the Dalai Lama, and as a result was jailed for six years during the Cultural Revolution. Later the Chinese returned the Panchen Lama to Tibet and showered him with favors in the hope

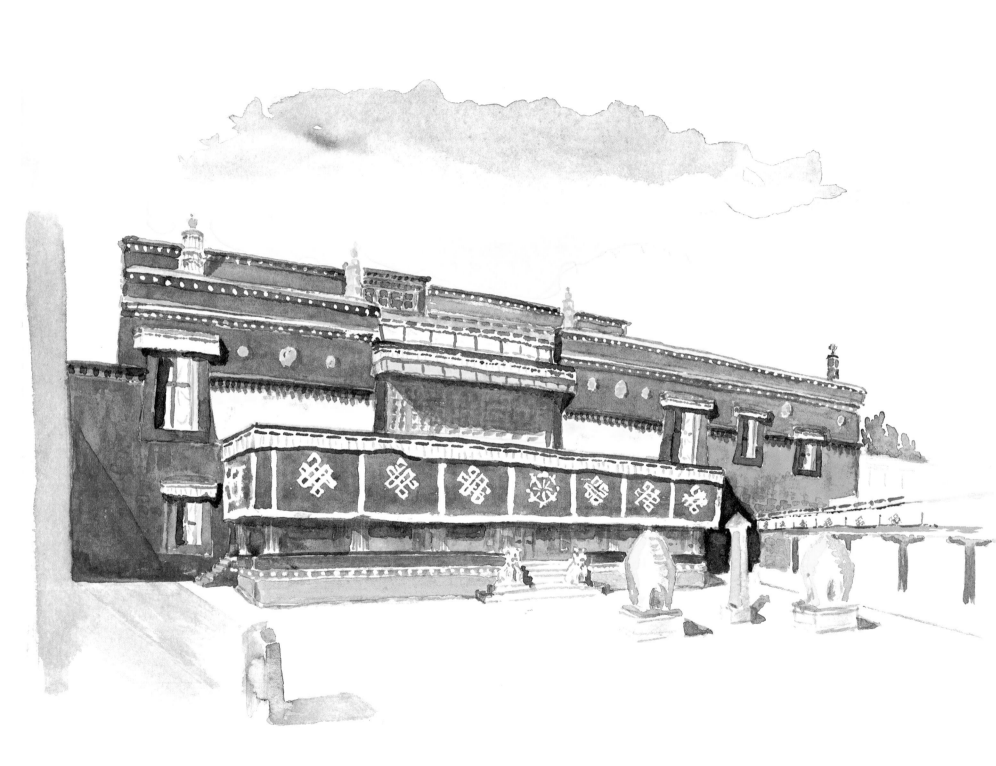

The State Oracle resided in Nechung monastery, which is dedicated to fierce divinities, before following the Fourteenth Dalai Lama into exile.

that he would replace the Dalai Lama, who had fled to India. In 1989, in his last speech, the Panchen Lama publicly declared his total subservience to the Dalai Lama and his opposition to the Chinese regime. The following day he died of a heart attack.

While Tashi Lhunpo grew in wealth, Lhasa flourished as well. Of prime importance to the rule of the Dalai Lamas was the State Oracle, who lived in the elegant monastery of Nechung below the huge monastery of Drepung, four miles west of Lhasa. Associated with Tantric beliefs in spirits and demons, fierce divinities and devils, the oracle is a direct descendant of the ancient shamans of central Asia. The Nechung Oracle, who is consulted on every important issue, followed the Dalai Lama into exile and continues to influence Tibetan politics.

The Manchu emperors of China were devoted Buddhists. Their faith in the Dalai Lama is still visible in Beijing today, where two very tall Tibetan chortens rise along the skyline. Known as the White Dagoda, the tallest chorten of Tibet was first erected on the occasion of the Fifth Dalai Lama's visit to Beijing in the seventeenth century. It stands on a hill on an island in the ornamental lake of Beihai Park, built on the site of what was believed to be Kublai Khan's palace. Rebuilt in 1741, the chorten is one of many Tibetan-inspired structures found in China. On the grounds of the summer palace of Chende, Emperor Quianlong even built an imitation of the Potala, begun in 1790. Throughout China, Buddhist monasteries attest to the influence of Tibetan architecture and the faith of the Manchu emperors.

In the beginning of the modern era, central Tibet remained isolated, cut off from the world by the Dalai Lama's conservative government. The monks were suspicious of modern technology and ideas, and central Tibet became a forbidden land. Access to Ladakh,

Three chortens.

127 The golden temple of Labrang, the largest monastery in what was northeastern Tibet.

Bhutan, Sikkim, and the Chinese Tibetan provinces of Qinghai and Kanting were also restricted by the British and the Chinese.

Irritated by the attitude of the monks in Tibet, who returned unopened the letters sent to the Dalai Lama, Lord Curzon, the viceroy of India, decided in 1903 to invade Tibet to teach the monks a lesson. This shameful invasion met with little or no resistance. After massacring hundreds of poorly armed Tibetan peasants at Guru and blowing up the fort of Phari and most of the fabulous citadel of Gyantse, the British entered Lhasa. This invasion brought about little or no change to Tibet, and public opinion at home eventually forced the British to withdraw.

The dynamic Thirteenth Dalai Lama attempted in vain to modernize Tibet's army and institutions, only to meet opposition from the all-powerful conservative religious hierarchs, the heads of the land's principal monasteries. The monks forced the closure of an English school in Gyantse and limited the modernization of the army.

The Thirteenth Dalai Lama died in 1933. His testament warned the Tibetan people against the rising menace of Communism, whose followers in 1924 had taken control of Mongolia and destroyed its monasteries; but no one listened. On the contrary, Tibet reverted to its medieval religious intrigues. The progressive minister Lungshar, who wanted Tibet to modernize, was punished in 1935 by having his eyes gouged out, while the regent, Reting Rinpoche, proved to be a dissolute and crooked monk who was eventually ousted and then murdered. The young Fourteenth Dalai Lama proved to be more interested in religion than politics, and he and his conservative cabinet believed that the Communist Chinese—with whom Tibet had so much history and culture in common—would be better for Tibet than Britain. Thus, Tibet

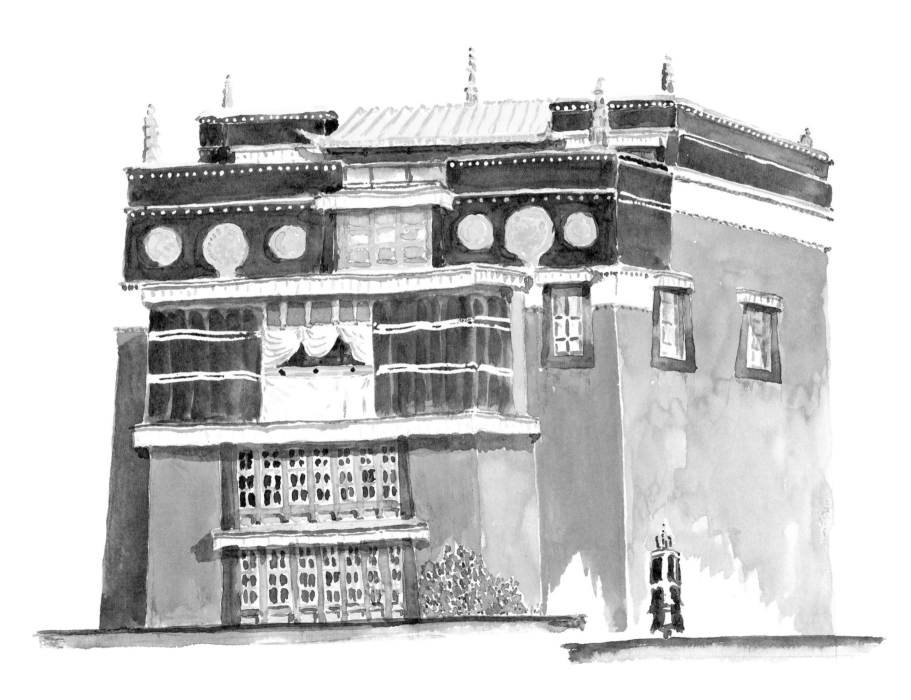

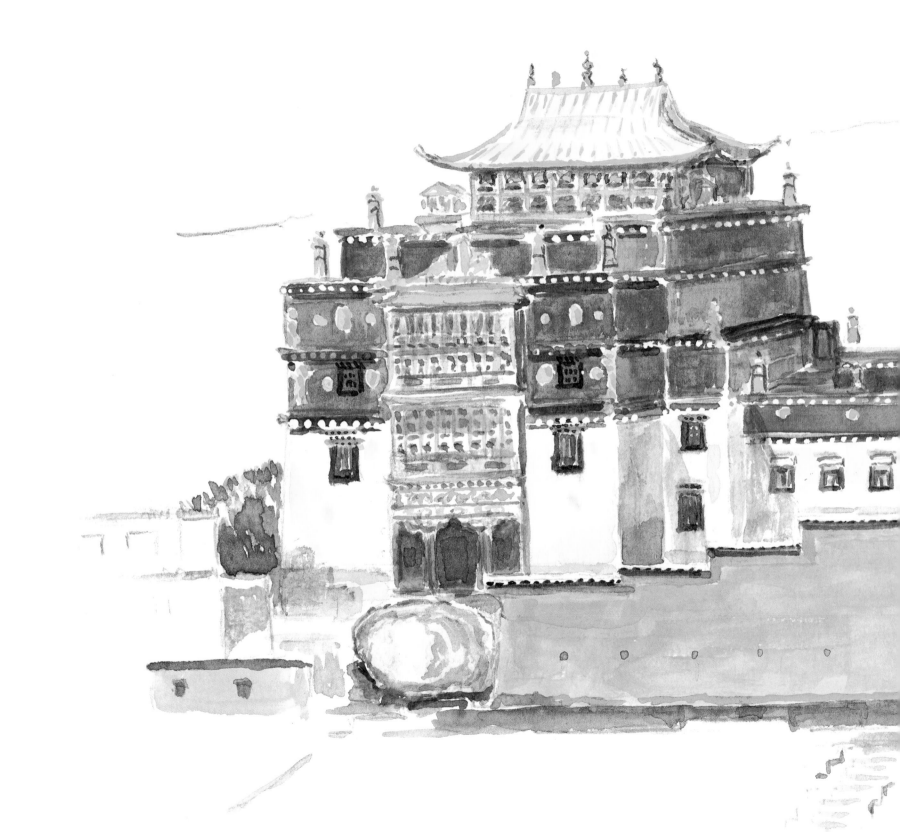

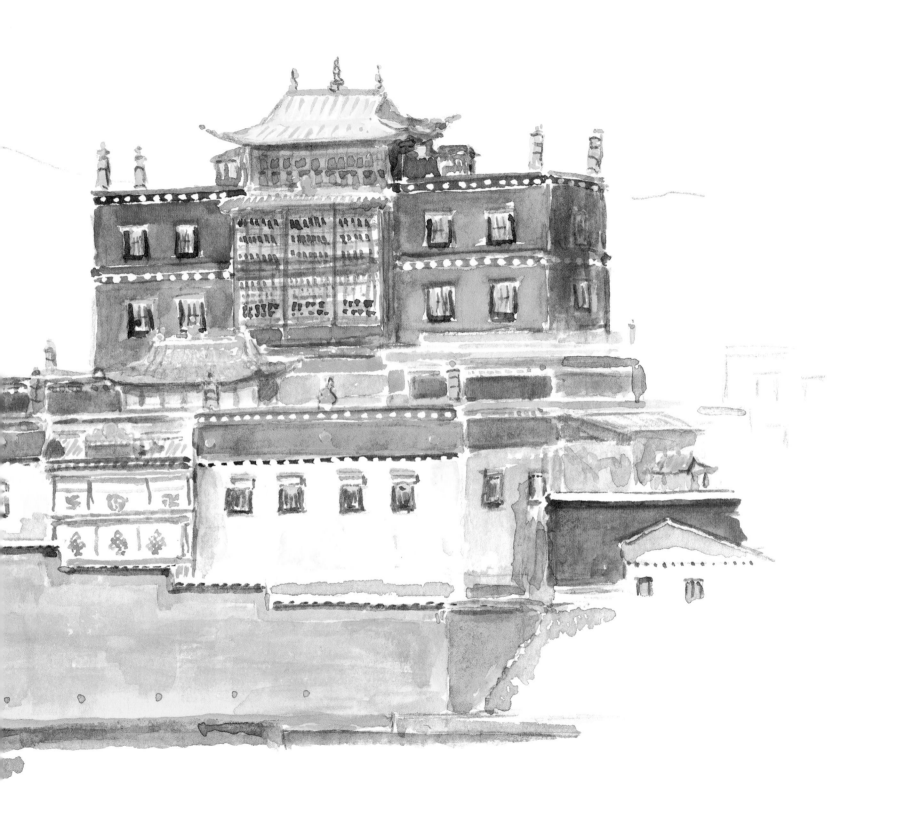

128–129 Sumsanling monastery in Gyalthang, founded by the Fifth Dalai Lama, marks the southeastern limits of former Tibetan territory in Yunan.

Today, the Rumtek monastery in Sikkim is the seat of the Karma Kagyu order.

threw itself at the mercy of Mao, whom the young and innocent Dalai Lama described as a shining light for the future.

After collaborating with the Chinese for nine years and betraying eastern and northern Tibet, the Dalai Lama realized his mistake too late. Fleeing Lhasa in the spring of 1959, His Holiness proclaimed that Tibet should be united once again with Kham and Amdo to oppose the Chinese. After this declaration at Lhunste Dzong, Tibetan freedom fighters escorted the Dalai Lama to the Indian border.

In all logic the failure of the Tibetan uprising of 1959 should have spelled the end of the Tibetan world. But this was far from true. The flight of the Dalai Lama and 100,000 refugees to India and Nepal brought the issue to the world's attention. Today all the peoples of ancient Tibet, from Muslim Baltistan in the far west to the Tibetan prefectures in Gansu in the east, are aware that they belong to the same nation—not the political Tibet of the Dalai Lamas but the great nation of the ancient kings of Tibet.

Tibetan architecture remains vital today. In this century the large monastery of Sumsanling, originally constructed by the Fifth Dalai Lama, was entirely rebuilt in the traditional Tibetan style. The monastery stands in the old Tibetan town of Gyalthang, now called Zongdian by the Chinese, in Yunan. Yet despite Chinese rule, the ethnic Tibetans of the region have continued the architectural traditions of their heritage.

Fortresses, palaces, and monasteries across Tibet are being rebuilt or restored today, according to traditions that prove that Tibetan culture is still very much alive. There is no reason to doubt that the Tibetan nation will outlive the political turmoils of religion and Communism that have caused its momentary eclipse and hopefully Tibet will one day regain its freedom.

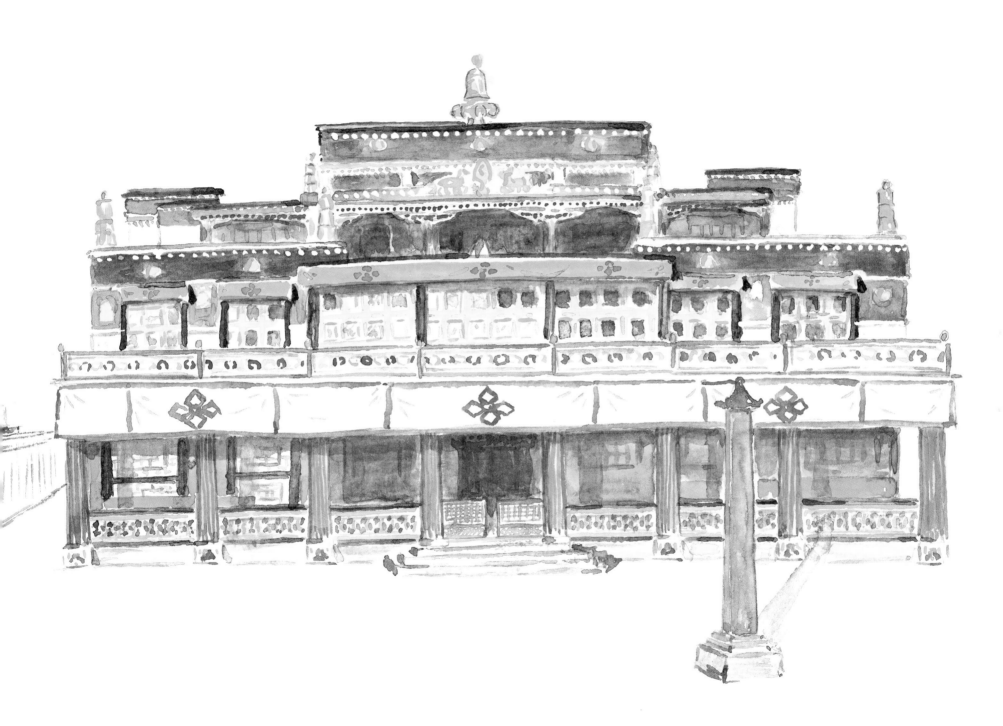

Expeditions and journeys of Michel Peissel to Tibetan-speaking regions of central Asia

1959 Anthropological survey of Mt. Everest region; study of the Sherpas.

1964 Exploration and study of the Kingdom of Mustang; discovery of the first "Mollas" (historical chronicles).

1966–67 Research in Nepal on Mustang and the survival of the Scythian "animal-style" art in Tibet.

1968 Anthropological exploration of eastern Bhutan.

1972 Expedition by hovercraft through the Great Himalayan Breach between Mt. Annapurna and Mt. Dhaulagiri.

1975 Expedition to Ladakh.

1976 First anthropological study of Zanskar.

1977 Trans-Himalayan expedition from Kitchwar to Leh.

1978 Filming expedition in Zanskar with BBC-TV.

1980 Expedition to the Ralagong Valley and the discovery of Minaro settlements in Zanskar; winter expedition to the source of the Ganges via Machel.

1981 Study of Minaro of the upper Indus; recording of archaic Shina vocabulary.

1982 Expedition into the no man's land along the India-Pakistan ceasefire line in search of the gold fields of Herodotus; winter expedition around Mt. Minya Konka in Kham, in eastern Tibet.

1986 Expedition to the tropical Tibetan regions of Pemako and Tsari, along the great bend of the Brahmaputra River.

1991 Second expedition to Mustang, to investigate cave sites.

1992 Expedition to study horse breeds and horse care in Tibet for the Loël Guinness Foundation.

1993 Expedition to southern Qinghai to study the Nangchen thoroughbred horse.

1994 Spring journey to Lhasa to translate a treaty on equine pharmacology; September, discovery of the principal (historical) source of the Mekong River.

1995 Expedition to northern Tibet, leading to the identification of an archaic breed of horses in Riwoche.

1996 Expedition to the Dansar plateau in Baltistan to find the giant gold-digging "ants" of Herodotus: marmots whose burrows contain gold dust.

1997 Expedition to Guge and western Tibet in search of cave sites and salt routes.

1998 Expedition to the lake Aru Tso in the heart of the western Changthang plateau; filming of Tibetan grizzly bear, blue sheep, and wild yak.

1999 Expedition across Changthang, financed by the Loël Guinness Foundation, to study the Sengo nomads and film local wildlife.

2000 Journey to Amdo, in northern Tibet, and Kongpo, in eastern Tibet.

2002 Journey to Pe Yul and other areas of eastern Tibet in search of animal-style art objects and other Scythian traditions.

2003 Journey to lower Mustang and then Patan, to study bronze casting.

Glossary

Adobe Tibetan adobe is a mixture of earth and yak dung, wetted and shaped into bricks that are dried in the sun. Adobe can also serve as a glue between wooden boards.

Bodhisattva A person devoted to "altruistic activity," who, upon attaining Buddahood, returns or remains on earth to help others on the path to enlightenment.

Chorten Tibetan version of the stupa in India. It is a funerary monument but can also contain manuscripts and other religious objects. The chorten is a symbol of enlightenment.

Dalai Lama The reincarnate lama of the Geluk school od Buddhism. The title of *Ta le* (Dalai) was bestowed on Sonam Gyatso by Altan Khan, leader of one of the Mongol tribes; it is the Mongolian translation of the Tibetan word *Gyatso*, which means "ocean." *Lama* is the Tibetan word for a spiritual teacher. In 1642 the Fifth Dalai Lama was made ruler of Tibet by Gushi Khan, the head of the Qosot Mongols. In 1959 the Fourteenth Dalai Lama fled Chinese-occupied Tibet. He leads the Tibetan government in exile in Dharamsala, India.

Dharma Raja Title meaning "religious king," which was given by the British in the nineteenth century to the reincarnate lama who ruled Bhutan. In 1907 the Dharma Raja was replaced by Urgyen Wangchuk, the first secular king of Bhutan.

Drolma Tibetan name of a popular female bodhisattva, known as Tara in India. She is represented artistically with the colors white, black, blue, and red; each color is associated with a particular virtue.

Dzong Fort or seat of local authority.

Geluk order The reformed school of Buddhism founded by Tsong Khapa in the early fifteenth century, which stresses meditation as opposed to magical rituals. It is the order of the Dalai Lama. (Gelukpa: A member of the order; Geluk monks are also known as "yellow hats.")

Kagyu Buddhist order founded by Marpa in the eleventh century. It stresses "oral transmission" of the doctrines. (Kagyupa: A member of the order.)

Kanjur A 108-volume collection of the words of Buddha, translated from Sanskrit. The Kanjur is a significant part of the Tibetan Buddhist canon.

Kar Fort or palace.

Karma An offshoot of the Kagyu school. (Karmapa: A member of the order.)

Lhakhang Chapel

Maitreya The Buddha "who is to come." Maitreya is the Sanskrit name for this bodhisattva; the Tibetan name is Champa. *See also* Sakyamuni.

Mandala A circular diagram for the performance of rituals. It usually depicts four gates and images of specific divinities. The mandala is a representation of the enlightenment and intended to help humans reach the sacred realm of the Buddha.

Mantra A sacred formula, made up of words, considered to have magical powers.

Nyingma The oldest school of Tibetan Buddhism, founded by Guru Rinpoche (Padmasambhava) in the late eighth century. (Nyingmapa: A member of the order.)

Panchen Lama Title given to the reincarnations of the teacher of the Fifth Dalai Lama, who head the enormous, wealthy Tashi Lhunpo monastery on the outskirts of Shigatse. A member of the same order as the Dalai Lama, the Geluk school, the Panchen Lama was often used by the Chinese to counter the authority of the Dalai Lama.

Sakya Semi-reformed order started in the eleventh century and centered around the Sakya monastery, founded in 1073 by Konchok Gyalpo. In the thirteenth century the Mongol leaders placed the Sakya monks in charge of Tibet and protected the country. The prominence of the Sakya order ended in 1368 when the Mongol Empire fell apart. (Sakyapa: A member of the order.)

Sakyamuni The historical Buddha, born Prince Siddhartha in approximately 563 BCE. He renounced his material possessions and achieved enlightenment.

Sutra A doctrinal text or discourse that provides instruction from the Buddha to his followers.

Tanjur Commentaries on Buddhist doctrine, collected in 225 volumes, which comprise the second major portion of the Tibetan canon.

Tsokhang Assembly hall in a monastery.

Other books by Michel Peissel

The Lost World of Quintana Roo. New York: E. P. Dutton, 1962, and London: Hodder & Stoughton, 1964.

Tiger for Breakfast: The Story of Boris of Kathmandu. New York: E. P. Dutton, 1966, and London: Hodder & Stoughton, 1967.

Mustang: A Lost Tibetan Kingdom. New York: E. P. Dutton, 1967, and London: Collins-Harvill, 1968.

Lords and Lamas: A Solitary Expedition across the Secret Himalayan Kingdom of Bhutan. London: Heinemann, 1970.

The Cavaliers of Kham: The Secret War in Tibet. London: Heinemann, 1972, and Boston: Little, Brown & Co., 1973.

The Great Himalayan Passage. London: Collins, 1974, and Boston: Little, Brown & Co., 1975.

Himalaya, continent secret. Paris: Flammarion, 1977.

Les Portes de l'or. Paris: Robert Laffont, 1978.

Zanskar: The Hidden Kingdom. New York: E. P. Dutton, 1979, and London: Harper Collins, 1980.

The Ant's Gold: The Discovery of the Greek El Dorado in the Himalayas. London: Harper Collins, 1984.

Royaumes de l'Himalaya. Paris: Bordas & Fils, 1986.

Itza ou le mystère du naufrage Maya. Paris: Robert Laffont, 1989.

La route de l'Ambre. Paris: Robert Laffont, 1992.

The Last Barbarians: The Discovery of the Source of the Mekong in Tibet. New York: Henry Holt & Company, 1997, and London: Souvenir Press Ltd., 1998.

Le Dernier horizon : À la découverte du Tibet inconnu. Paris: Robert Laffont, 2001.

Tibet: The Secret Continent. London: Cassell Illustrated, 2002, and New York: St. Martin's Press, 2003.